BOURNEMOUTH

THROUGH TIME

John Christopher

AMBERLEY PUBLISHING

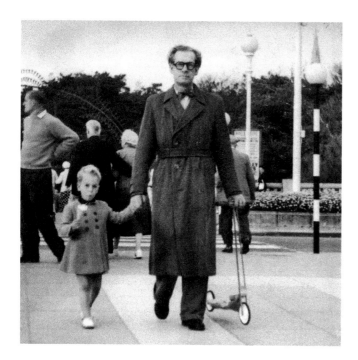

The author, aged three, with ice cream in one hand and his father in the other as they head towards Bournemouth Pier in late 1959. In the background you can see the archway entrance to the Lower Gardens, also shown on the left-hand side of the upper picture on page 31.

First published 2012

Amberley Publishing
The Hill, Stroud
Gloucestershire, GL5 4EP

www.amberley-books.com

Copyright © John Christopher, 2012

The right of John Christopher to be identified as the Author of this work has been asserted in accordance with the Copyrights, Designs and Patents Act 1988.

ISBN 978 1 4456 0353 7

British Library Cataloguing in Publication Data. A catalogue record for this book is available from the British Library.

Typeset in 9.5pt on 12pt Celeste.
Typesetting by Amberley Publishing.
Printed in the UK.

Introduction

Bournemouth is an unusual town in many respects. For a start it is very new. The official histories say it was founded in 1810 by Lewis Tregonwell, but there is little of the town that hasn't been built or laid out within the last 150 years or so, with much of it dating from the early to mid-twentieth century. Bournemouth is also a very big town. The main impetus behind this sudden spurt in growth was the coming of the railway in the 1880s, which in turn created and pandered to the new fashion for seaside holidays. Since then the town has expanded to the point where it has blended with its neighbours Poole, Boscombe, Winton, Pokesdown, Christchurch and so on, to the extent that the South East Dorset Conurbation has a combined population of almost 400,000, and that's not including the swarm of visitors that outnumber the locals during the summer months.

Bournemouth, consequently, represents many different things to different people. It all depends on your point of view. The holidaymakers see the town in terms of its postcard-perfect golden beaches, it pleasure gardens, shopping opportunities and entertainments. Other longer-term visitors include thousands of students, either attending the University or one of the countless foreign language schools that are clustered within the town. Then there are the residents for whom it is their home, a bustling urban sprawl that happens to be beside the sea. They are an assorted bunch ranging from the young trendy surf-loving professionals, right through the gamut of social groups to the blue-rinse brigade who have chosen the area for their retirement. The resulting mix gives the town great vibrancy and a cosmopolitan feel. Combine this with an exceptionally mild climate and it's no surprise that Bournemouth was declared as the happiest place to live in a recent nationwide poll.

So apart from the obvious outward growth, how has Bournemouth changed over its brief lifetime? Inevitably the development has reflected the fashions and changing fortunes of the seaside resort.

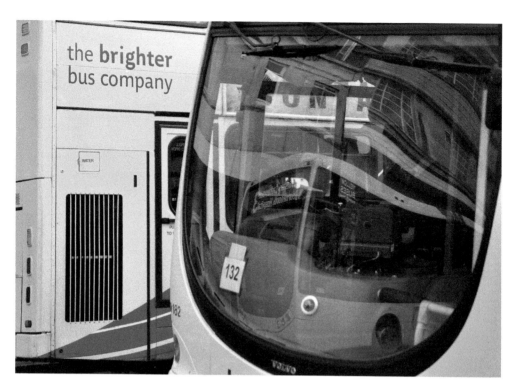

'Oh I Do Love to Be Beside the Seaside...'
Two iconic symbols of Bournemouth, the yellow buses and a row of beach huts photographed on the Undercliff Drive. There is a quality in the bright sunshine and clean seaside air that seems to give the bright colours an extra vibrancy.

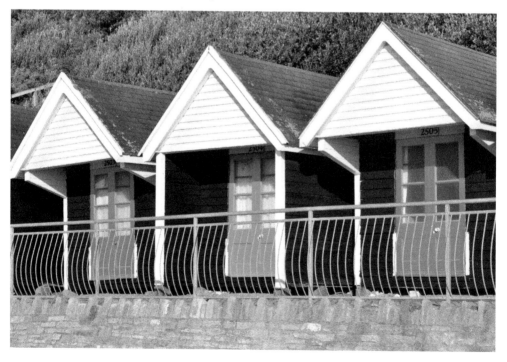

As you will see in the photographs, attractions such as the piers have prospered or declined with time, while newer attractions, such as the Bournemouth International Centre, have sprung up in their place to cater for different types of visitors. Just as with any large town, the individual areas have sometimes shifted in terms of their character or status, some becoming more fashionable while others less so.

This ebb and flow often goes hand in hand with the fabric of the town, its buildings in particular. As a result of its rapid growth within such a concentrated time span Bournemouth is blessed with a rich collection of architectural styles. These include many fine Victorian and Edwardian houses, hotels and public buildings – just take a look at the wonderful Russell-Cotes Museum on page 34. However, it was during the twentieth century that the town gained much of its distinct architectural flavour, in particular through the angular styling of the 1920s onwards – although the term 'Art Deco' wasn't coined until much later – and leading on to the more curvy lines of the 'Moderne' movement that thrived into the 1950s. These influences are also to be found in the more elusive genre of seaside architecture, one which has been generally overlooked or unappreciated, until now. It is best typified by the entrance building to Boscombe pier – see page 68 – which has become the centrepiece of the new Boscombe Spa Village development, another example of the changes and cycles in fashion that continue to shape the town.

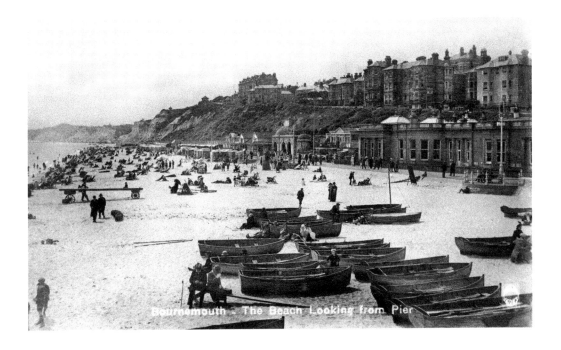

Bournemouth - The Beach Looking from Pier

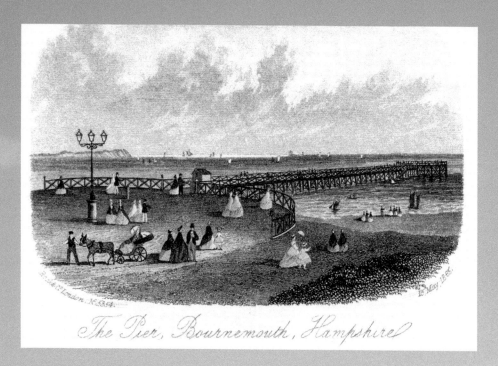

The Pier, Bournemouth, Hampshire

Bournemouth Pier

The first pier was a simple 100-foot jetty erected in 1856. It was replaced in 1861 by a 1,000-foot wooden pier designed by George Rennie, as shown in this 1865 illustration. This is turn was demolished and Eugenius Birch designed a cast-iron pier 838 feet long, which was opened in 1880 and further extended in 1894 and 1905 to provide landing stages for excursion steamers. (*Bmth200*)

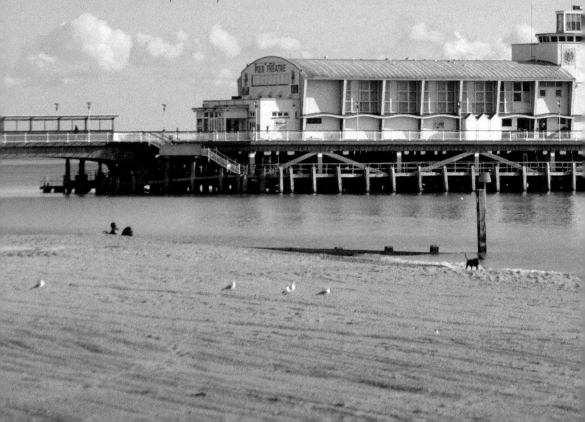

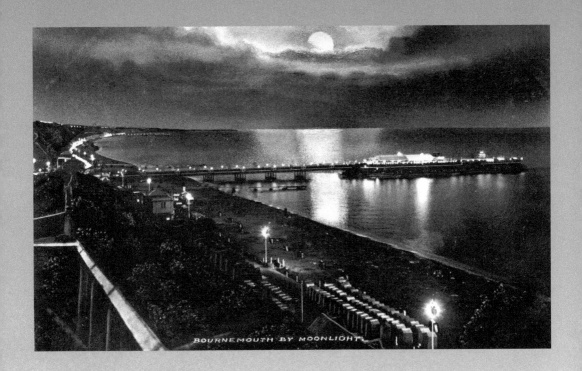

BOURNEMOUTH BY MOONLIGHT

In common with other towns on the southern and eastern coast, the pier was sectioned by an army demolition team in 1940 as a precaution against a German invasion. It was repaired and reopened after the war with the pier head refurbished in 1950 and a concrete substructure was completed in 1960 to support the weight of the new Pier Theatre. Seen from the side the profile of the pier has the feel of a ship with the tall stairwell structure rising up in the middle.

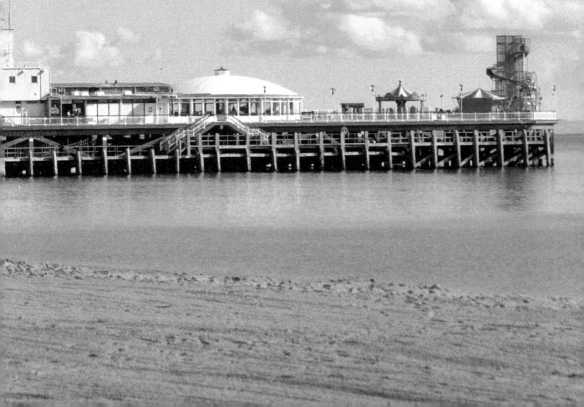

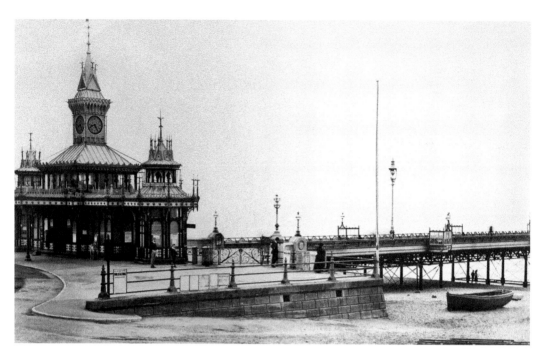

Pier Entrance Building

The original entrance building was a marvel of Victorian excess smothered with spikes and ornament, as revealed in this photograph from 1907. (*Bmth200*) In the 1950s it had been replaced by the still modestly proportioned red-brick and Portland stone building shown on page 30, but the 1981 refurbishment of the pier resulted in the construction of this overblown two-storey octagonal leisure complex, which houses shop kiosks, a bar, multi-purpose hall and an amusement arcade. Its lacklustre towers pay only a passing tribute to the Victorian original, and finished in garish white it lacks any of the charm of its predecessors.

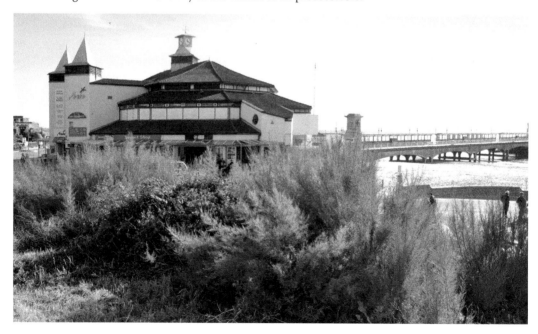

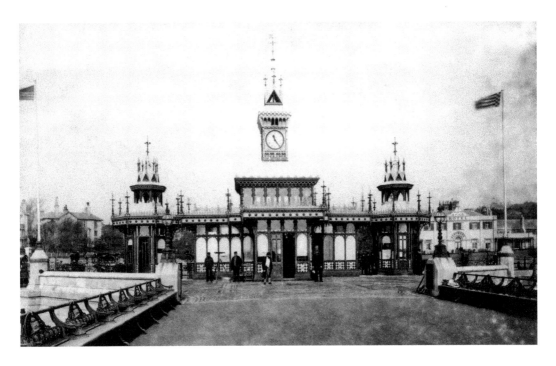

Entrances and Exits

The Victorian entrance, looking back towards the town from Bournemouth's replacement pier, which opened in 1880. This was a small building with only the bare essentials and the hotels glimpsed in the background show how the beach and the town blended on a far more intimate scale. (*Bmth200*) In the 2011 view the pier has lost its cast-iron benches, but has gained central weather shelters and a modern leisure complex at the entrance, while the town has gained a big balloon – see page 93.

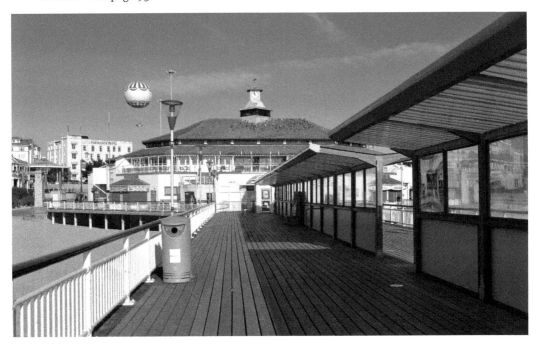

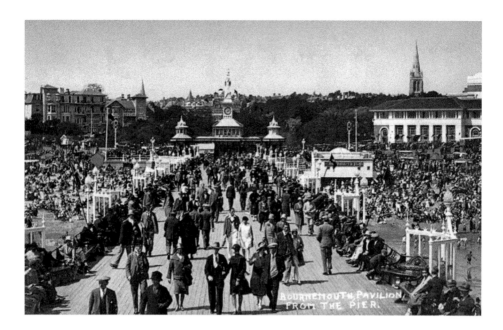

Pier Pressure

As well as providing a landing stage for the excursion steamers, the pier became an extension of the Promenade and remained a popular attraction. This postcard dates from the late 1920s and shows the old Victorian entrance, albeit slightly de-spiked, and the new Pavilion building in the background. The beach and the pier are both crammed with visitors. The small structure seen to the right of the pier is a booth for one of the groups of performing players. If the modern scene seems almost deserted by comparison, it should be explained that this photograph was taken on a weekday morning in October.

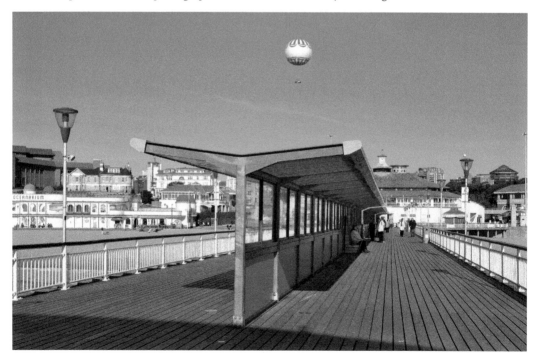

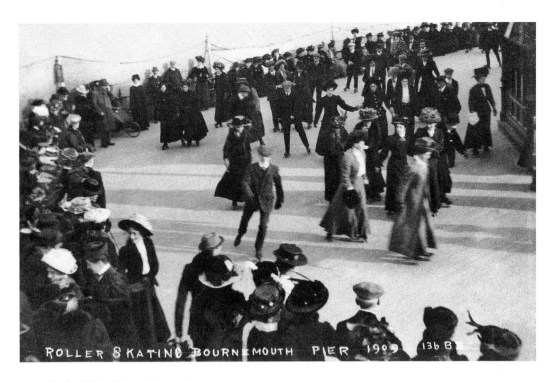

ROLLER SKATING BOURNEMOUTH PIER 1909 136 B

End of Pier Entertainments

For those who wanted more than a casual stroll they could go roller skating at the end of the pier, although what the health and safety people would make of it is hard to say. In this fantastic photograph from 1909 skaters and spectators are all very properly attired with dark coats and hats. The pier head also had a bandstand, although today's entertainments are a little gaudier. (*CMcC*)

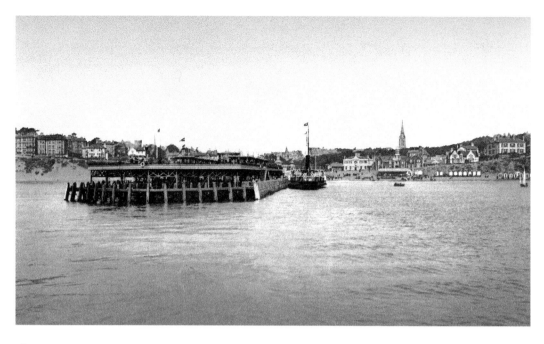

Pier Improvements

As this early photograph clearly shows, the pier was a very plain and functional structure with a minimum of facilities apart from covered shelters and bandstand, which were added in 1855. Note the bathing carriages lined up on the beach. These were wheeled to the edge of the water to enable the bathers, especially the women, to enter the sea with appropriate modesty. The current buildings, including the Pier Theatre, were added after the reconstruction of the pier itself in the 1950s and their styling have given it a decidedly nautical air with a hint of 'Seaside-Moderne'. (*LoC*)

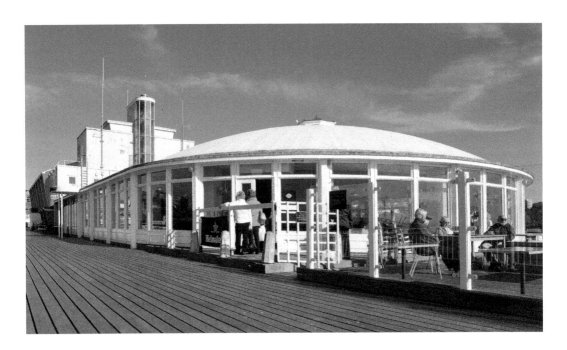

Pier Buildings

Looking at the existing structure on the pier you might be forgiven for thinking that you were on-board a ship. Note the detailing on the side of the Pier Theatre, which echoes the Undercliff Drive beach huts shown on page 70. All this could be under threat as the Pier's operators seek new ways to attract visitors. Proposals for a big wheel and viewing tower have been rejected, but in September 2011 the planners gave the go-ahead for the theatre to be replaced with a variety of all-weather sporting attractions including a standing-wave surfing machine.

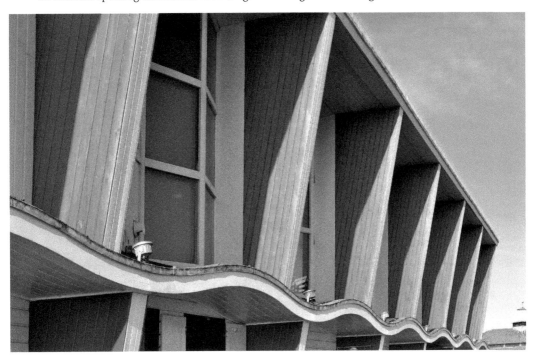

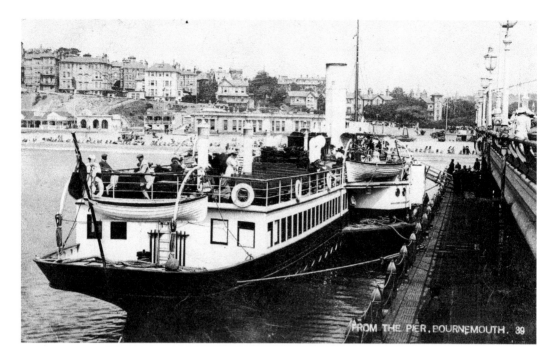

Excursion Steamers at Bournemouth

A paddle steamer docked on the landing stage on the west side of the pier, *c.* 1910. (*CMcC*) The first recorded excursion was by the steamer *Fawn* on a chartered trip to Spithead in 1868. The pier head has retained the landing stages on both sides – see opposite page – and the *Waverley* paddle ship, built on the Clyde just after the war, remains a regular visitor to Bournemouth and, along with the former Red Funnel steamer *Balmoral,* offers a variety of excursion trips along the coast.

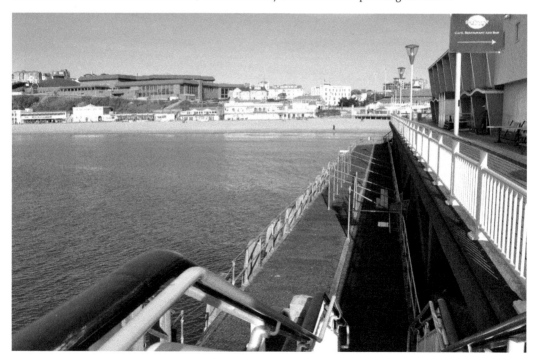

The Victoria

A slightly later view of the small paddle steamer *Victoria* moored on the eastern side of the pier. Registered in Weymouth, the *Victoria* was operated by Cosens on excursions to a number of locations including Swanage, Weymouth, Lyme Regis and Lulworth Cove – see overleaf. The *Victoria* was built in Holland in 1884, lengthened in 1888 and continued in service until 1953. Judging by the buildings in the background this photograph must have been taken quite late in her career. (*CMcC*)

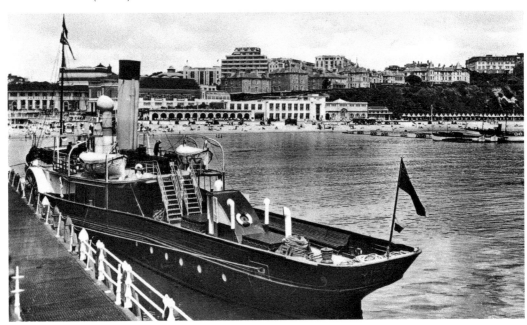

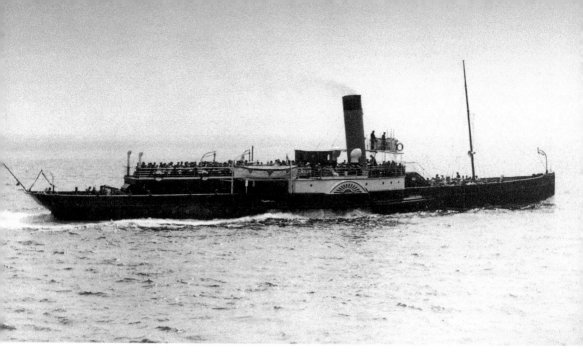

Paddle Steamers

SS *Consul* on one of her regular excursions from Bournemouth along the South Coast. Built in 1896, she began life as the *Duke of Devonshire* and the name was changed to *Consul* when Cosens bought her in 1938. In the lower photograph the *Victoria* demonstrates the method of getting passengers on and off the ship at Lulworth Cove, which is situated roughly halfway between Swanage and Weymouth. (*CMcC*)

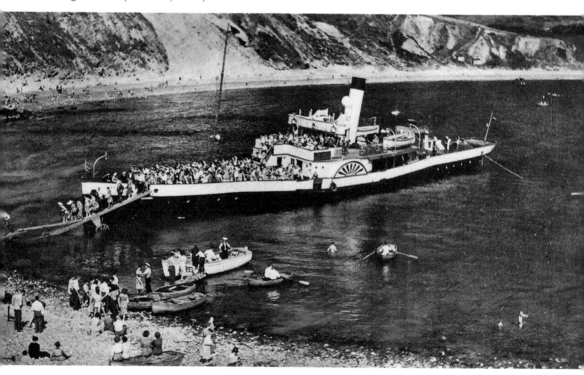

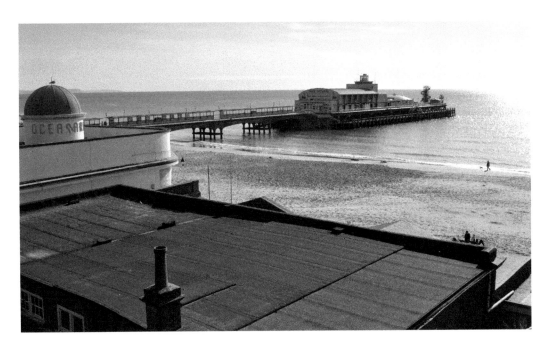

Seaside Concert Parties

A throng of onlookers gathers around to see a performance by Willie West's Bohemian Concert Party, c. 1895. Note the dog on the stage. Such troupes were a common entertainment along the seafront, especially around the busy pier. In the later photograph the Promenade is occupied by assorted buildings, including the Oceanarium to the left. The Pier Theatre, in the background, was popular enough in the 1960s and 1970s, but nowadays its audiences have dwindled and it is scheduled to close soon. (Bmth200)

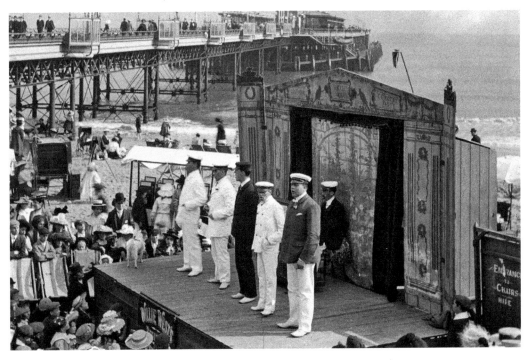

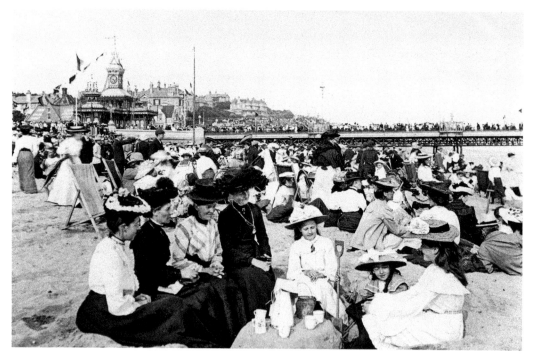

On the Beach

Enjoying the simple delights of the beach, on the west side of the pier, *c.* 1905. Every square inch of the sands and pier seems to be packed with people, and although the modern trend for 'stay-cations' has brought holidaymakers back to Britain's seaside resorts it is hard to imagine such crowded scenes again. Note the young girls equipped with buckets and spades but still dressed from head to toe. The Russell-Cotes building is visible on the East Cliff beyond the pier. (*Bmth200*)

West Cliff Promenade

Commercial development of the Pier Approach and surrounding area has seen the loss of many smaller establishments, such as the Bourne Hotel, which was on the corner of the West Cliff Promenade and Exeter Road curving upwards on the right. This site is now occupied by the Hot Rods bar and restaurant. The modern church spire, seen on the far right of Exeter Road, belongs to the Punshon Memorial Methodist church and this faces demolition to make way for a new 110-bedroom hotel.

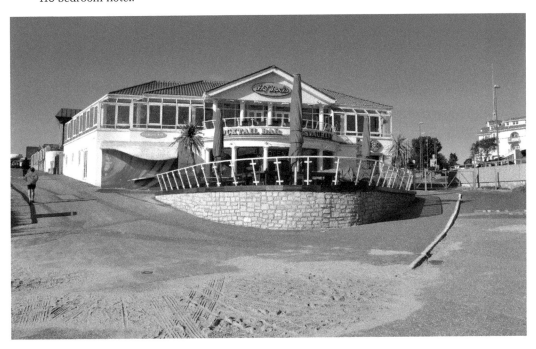

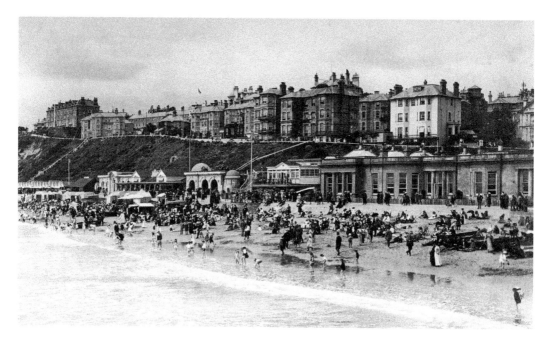

West Cliff

Like layers of history – three views looking westwards from the pier. The earliest is *c.* 1910, the one on the opposite page comes from around 1960 and the panoramic view, *below*, was taken in October 2011. Some of the cliff-top hotel buildings are still present, and there are several common reference points between the photographs. For example, at the far left on the top of the cliff there is the dome of the old Tollard Royal Hotel – see page 23.

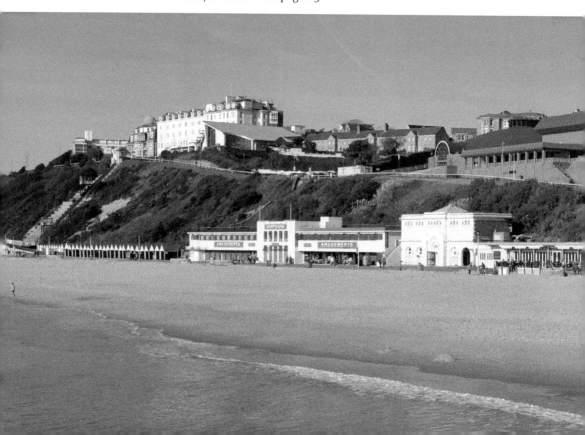

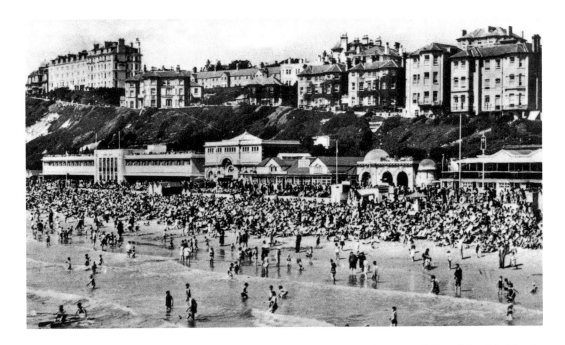

The most obvious difference, or should I say intrusion, is that monolithic slab of brick, the Bournemouth International Centre (or BIC), which opened in 1984. What on Earth persuaded the planners to permit construction of this vast plain red-brick structure in a setting that is singularly lacking in similar buildings? No doubt they would argue that it is an important venue for conferences and concerts and brings untold custom to the town. The large white building on the seafront, to the far right on the 2011 photo, is the Oceanarium.

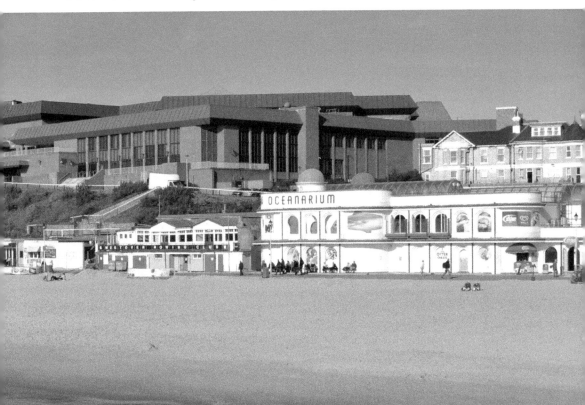

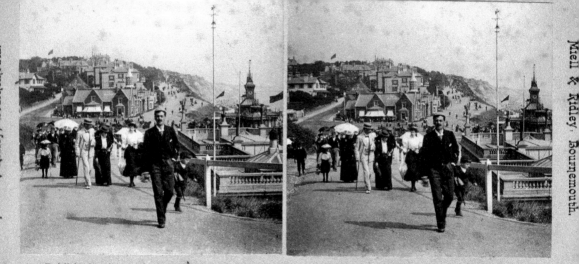

Miell & Ridley, Bournemouth.

Published only by J. E. BEALE, The Fancy Fair, and Oriental House, BOURNEMOUTH.

West Cliff Promenade

Looking down from the West Cliff towards the Pier Approach. Stereoscopic or 3D photo cards such as this one, published by J. E. Beale of Bournemouth, were a very popular novelty in late Victorian and also Edwardian times and many were produced as souvenirs. In the background the main building is the swimming baths and reading room, and on the far right there is the pier entrance and the corner of the back of a stone building, which also can be seen to the right of the picture on the top of page 20. In the modern photo the mirror-glass IMAX building dominates the scene, and on the far right the Oceanarium occupies the site of the old stone building.

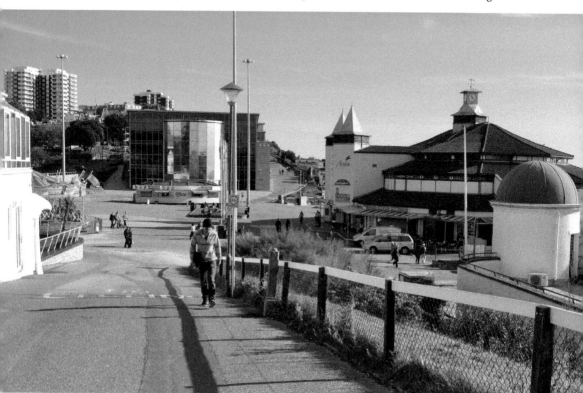

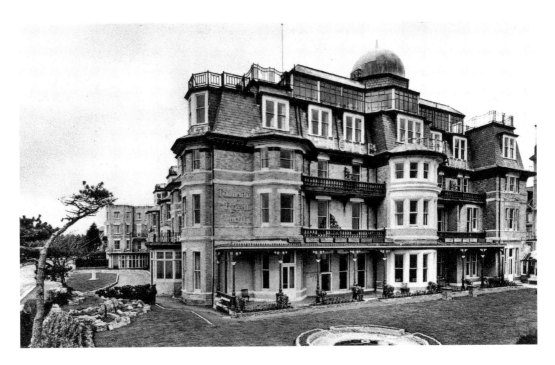

Tolland Royal Hotel

Continuing up the West Cliff and past the BIC you come to the former Tollard Royal Hotel on the corner of St Michael's Road and West Hill Road. Once a major hotel in the area this building, with its landmark copper-sheathed dome, is now divided into private apartments. The conversion of the roof flat or penthouse featured on one of Kevin McCleod's *Grand Designs* television programmes.

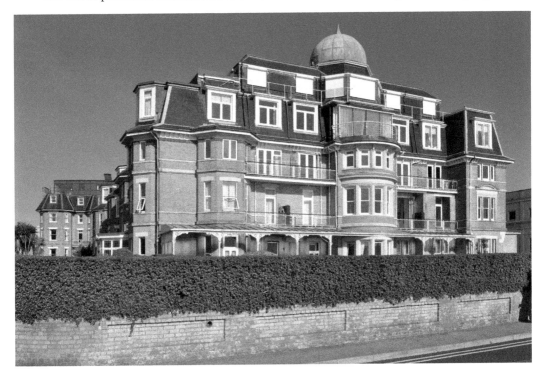

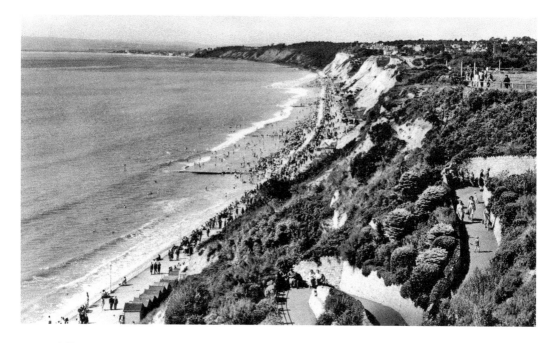

West Cliff Zigzag

Two views of the West Cliff zigzag looking to the west with the chines and, in the distance, Canford Cliffs and Sandbanks reaching out to the top left at the entrance to Poole Harbour. In the earlier image from around 1960 the sandstone cliffs are still exposed but more recently they have become increasingly covered by vegetation. This is because the Promenade has prevented the natural erosion of the cliffs. The bay, extending from Poole Harbour to Hengistbury Head in the east, is frequently referred to Bournemouth Bay, but this is a misnomer as it is actually Poole Bay. Bournemouth has two more zigzags, one on the East Cliff and another at Southbourne.

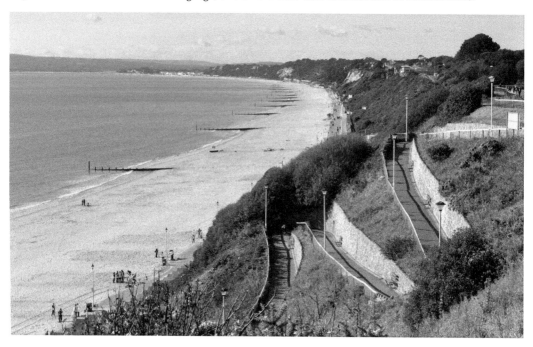

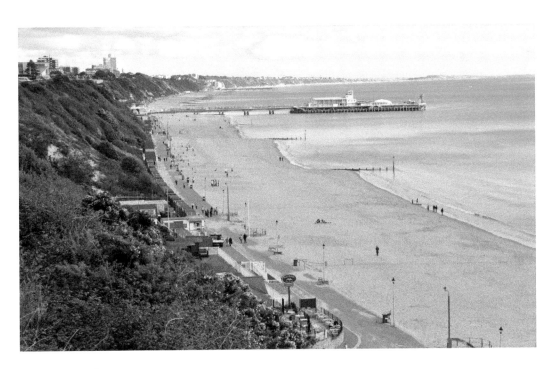

Durley Chine

Heading westwards there are several chines, steep-sided valleys cut into the soft sandstone – the word comes from the Saxon 'cinan' for gap. The first one reached after the zigzag is Durley Chine, shown here in the 1950s and in 2011. The curved café building has been replaced with a similar one for a Harvester restaurant, although the view can't be replicated because of the increase in vegetation.

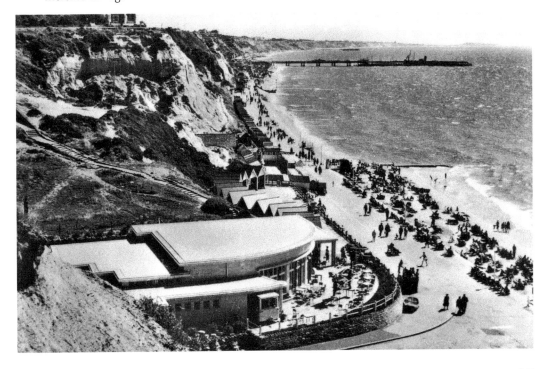

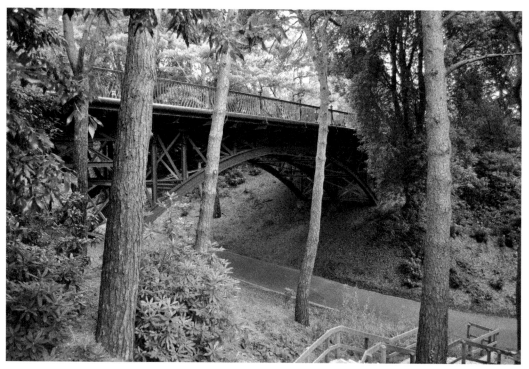

Chine Bridges

After Durley comes Middle Chine, a deep valley crossed by the West Overcliff Drive bridge, *above*. Continue west and you come to Alum Chine, a long, straight chine crossed by a footbridge shown on this postcard from around 1910. The caption reads, 'A pretty peep in Alum Chine, Bournemouth'.

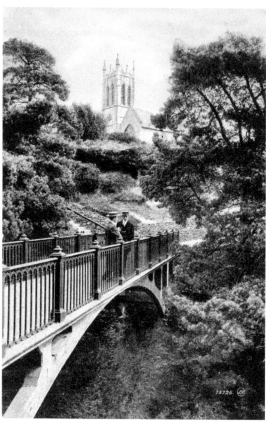

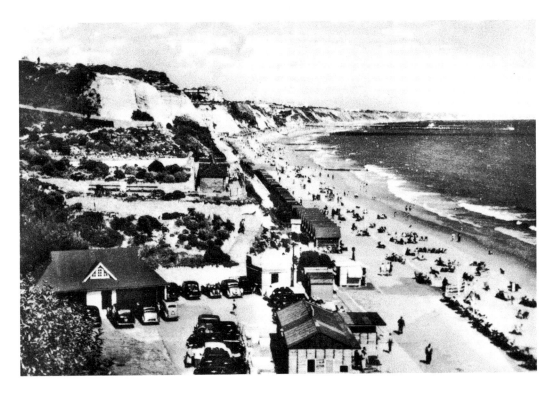

Alum and Middle Chines

Another 1950s photo, this time looking back towards from the pier and showing the cluster of buildings at the mouth of Alum Chine. Below, a deserted beach and lots of beach huts at Middle Chine, basking in the autumn sunshine. Further eastwards you eventually come to Branksome Chine, the biggest of the chines.

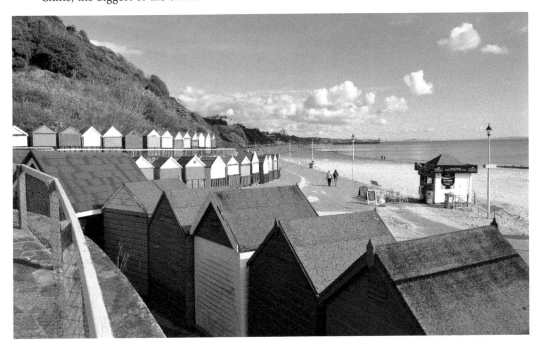

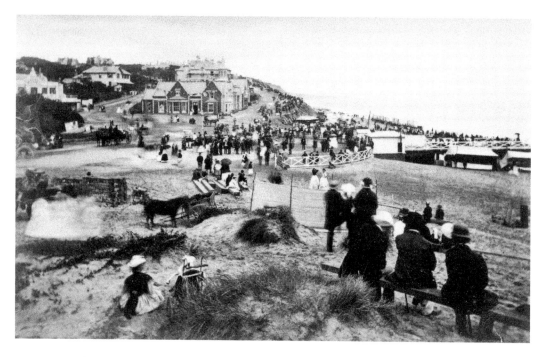

Pier Approach

Returning to the Pier Approach and this early photograph from *c*. 1875 shows the area almost in it natural form without a Promenade road. The pier has only the most basic wooden buildings at the entrance. (*Bmth200*) The new photograph shows the pier entrance, capped by a clock, with the Oceanarium in the foreground, right, and the East Cliff rising in the distance. On the left, Bath Road, or the B3066, leads up the hill past the white buildings of the first hotel in Bournemouth, the Royal Bath Hotel, which opened on Queen Victoria's coronation day in 1838.

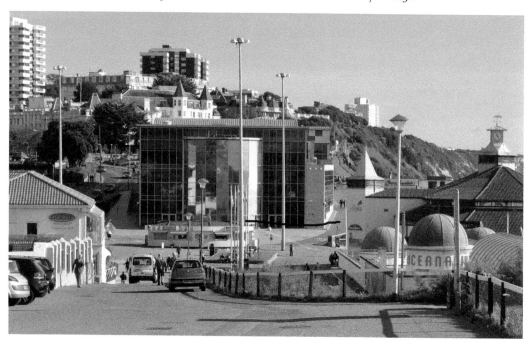

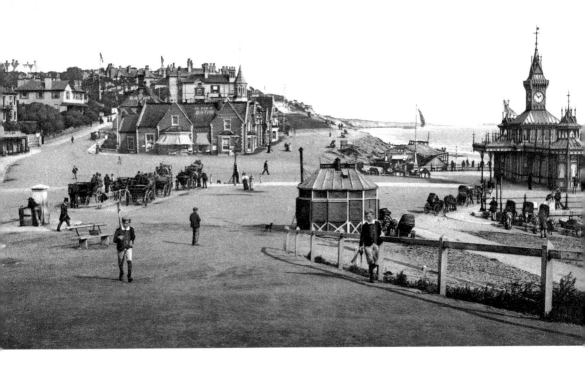

Pier Approach

The Victorian entrance to Bournemouth Pier, *c.* 1900, contrasted with the 1950s version. In the earlier image the swimming baths are indicated by the writing on the roof of the central building, but in the later one we see the purpose-built municipal baths. Note the single-decker Bournemouth Corporation yellow bus – see also page 81.

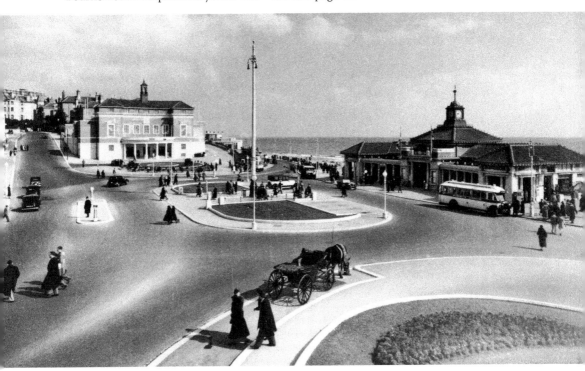

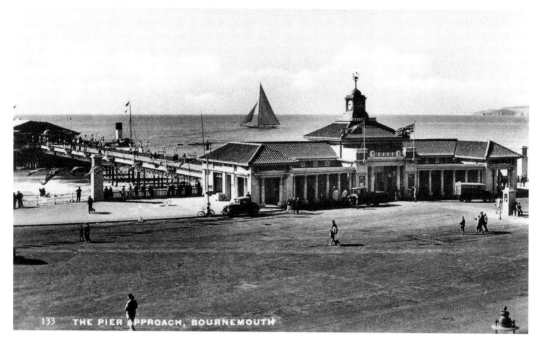

133 THE PIER APPROACH, BOURNEMOUTH

Pier Approach and Fly-Over

A view of Bournemouth Pier as seen from the Pavilion. The earlier image was taken a little before modifications were made to the Victorian pier in the 1950s. Note the big, open spaces in the approach area, and also the steamer moored alongside the pier. The modern image shows the new and much larger pier entrance building, the additional concrete substructure on the pier itself, and the approach, which is now crossed by this ugly fly-over.

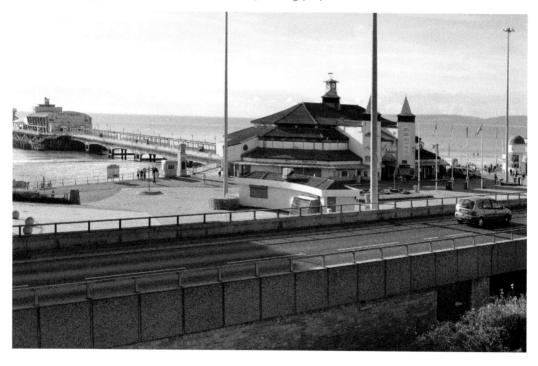

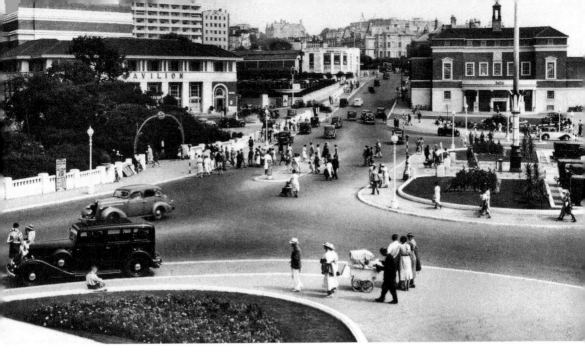

Bournemouth's Most Hated Building?

When the upper photograph was taken in the 1950s the pier approach was populated by a trio of municipal buildings, which had a pleasing commonality of building materials, architectural styles and scale. The Pavilion is the only survivor. The Pier Approach building got bigger while the Swimming Baths, centre, were demolished and replaced by the reflective cube of the IMAX building. This opened in 2002, closed three years later, and the site is going to be redeveloped. Watch this space.

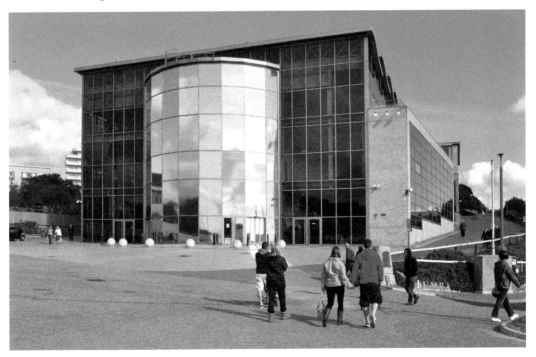

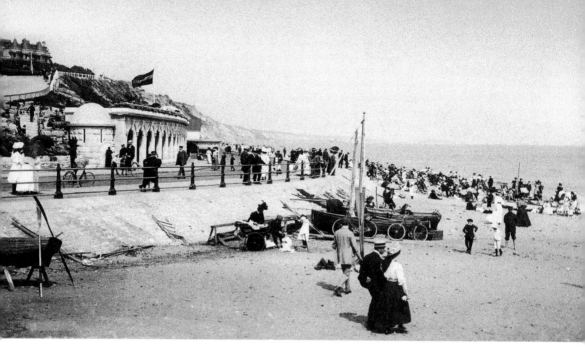

East Beach

Looking eastwards from the pier. The Russell-Cotes building can be glimpsed on the top of the cliff. You won't see any boats on the beach nowadays, but note the level of the sands. The building of the Promenade Road and other sea defences halted the natural process of erosion that replenished the sands and an extensive programme of replenishment with sand dredged from the bay was needed to raise the level in recent years.

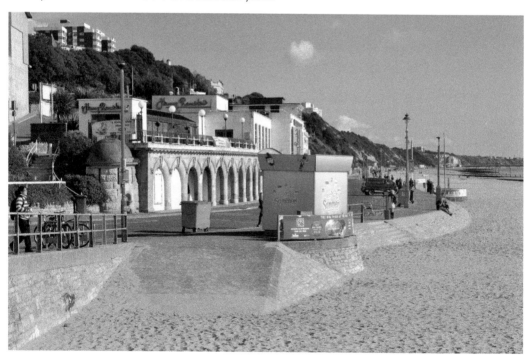

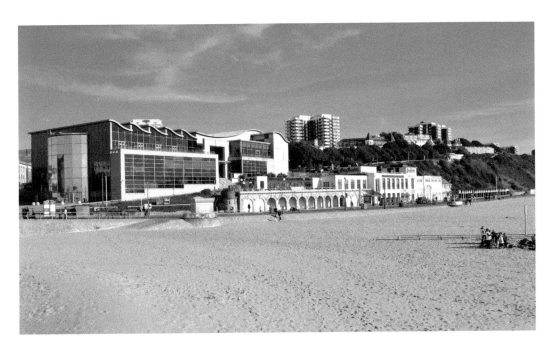

East Cliff

Viewed from the pier, the East Cliff and beach. From the left, the mirrored panels of the redundant IMAX building, then up the gentle path there are the twin white towers of the Royal Bath Hotel on Bath Road and, to the right, the points of the Russell-Cotes Art Gallery & Museum. The buildings on the Promenade have hardly changed since the 1950s photo was taken, although the East Cliff Café is now a Harry Ramsden's fish and chip restaurant. Note the wheeled walkway on the beach, in the earlier image, used to board smaller pleasure boats that were not big enough to moor at the pier.

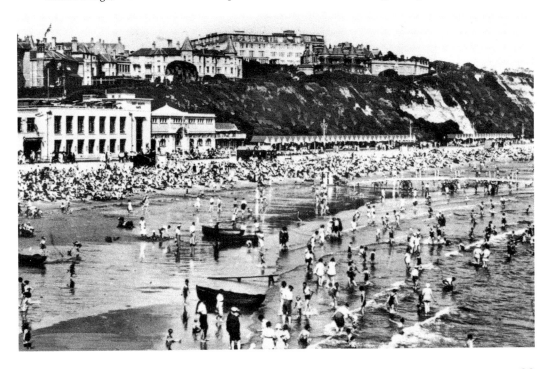

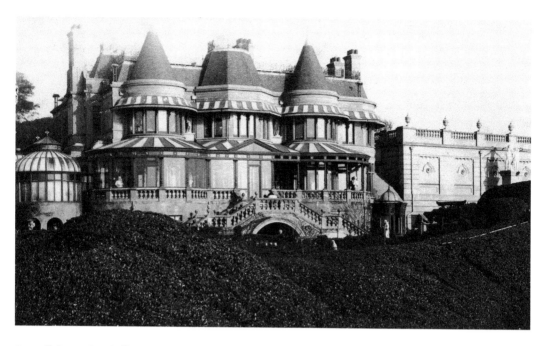

Russell-Cotes Art Gallery & Museum

This gem is one of Bournemouth's best-known secrets. Originally the home of Sir Merton and Lady Russell-Cotes, it was designed by local architect John Frederick Fogerty in a combination of Scottish Baronial and Italian Renaissance styles. The Russell-Cotes filled their house with curios collected on their world travels and upon their deaths the house was left to the people of Bournemouth. Four art galleries were added to the building in the 1920s to showcase the Russell-Cotes art collection and it has continued as an art gallery and museum ever since.

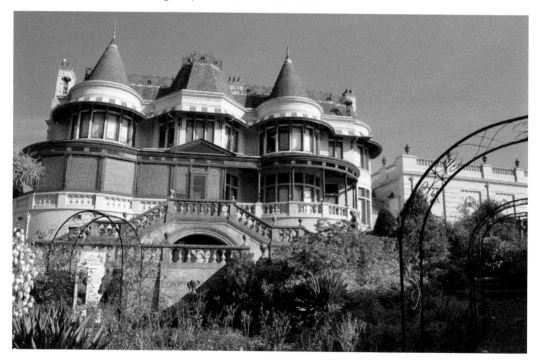

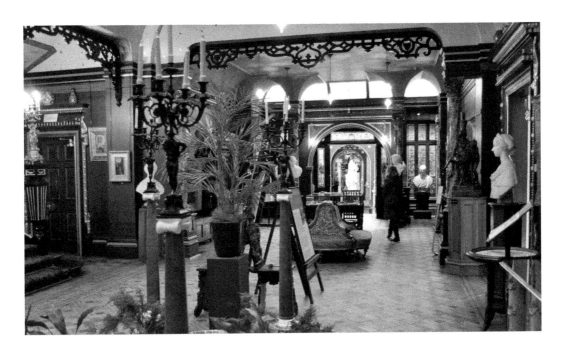

Russell-Cotes Building, the Main Hall

The Russell-Cotes is an extraordinary time capsule of Victorian and Edwardian taste. Construction of the main part of the building was completed in 1901, and to this day it still conveys the impression that you have entered someone's private house, a very eccentric one at that. In recent years funding from the National Lottery Heritage Fund has enabled its further development into a first-rate museum. Great efforts have been made to recapture the sense of this being a real home and the later galleries present an interesting and unusual array of art and sculpture. Best of all, admission is free.

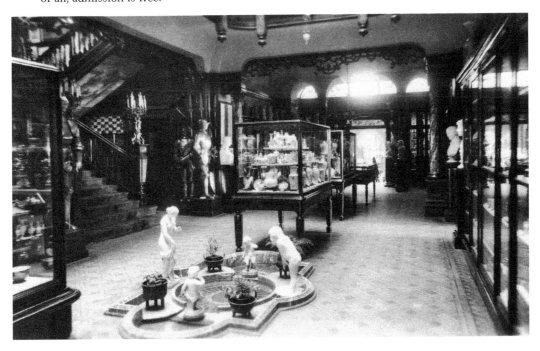

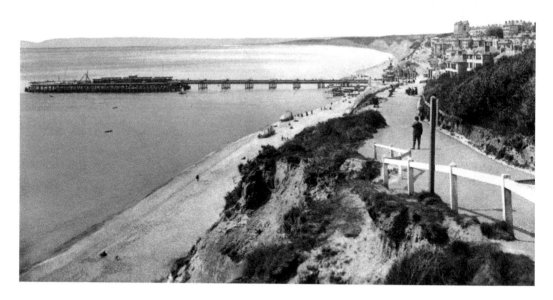

East Cliff Path

Looking back towards the pier and across Poole Bay. The Victorian pier has a bare minimum of superstructure, just shelters and a bandstand. The buildings of the town are clustered around the valley and there is no Promenade road. Consequently the yellow cliffs remain clear of vegetation. On the far side of the bay are the Purbeck Hills with Swanage tucked behind the Old Harry Rocks at Handfast Point on the left-hand side. (*LoC*)

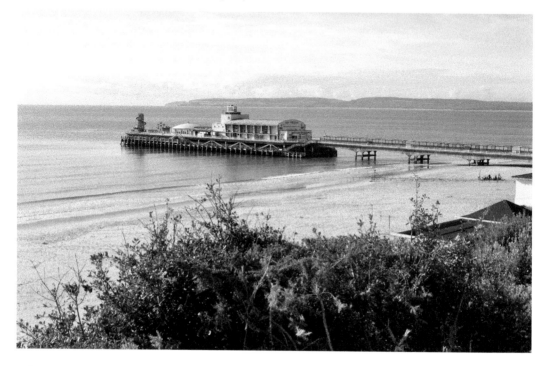

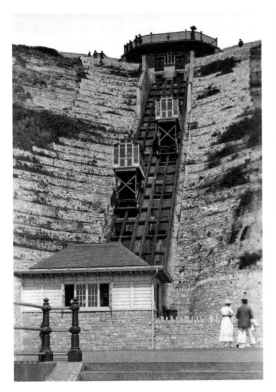
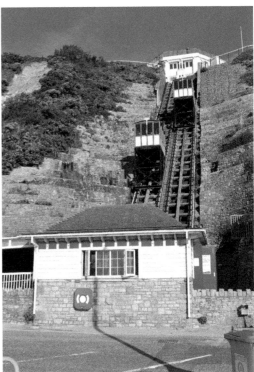

Bournemouth's Cliff Railways

The East Cliff Railway, or lift, was opened by Lady Meyrick in April 1908. Its two passenger cars travel 170 feet on parallel tracks up and down the cliff, with the winding gear contained in the upper 'station' building. It is the oldest of the town's three cliff railways, the others being on the West Cliff, shown *below*, and at Fisherman's Walk, Southbourne – see page 76.

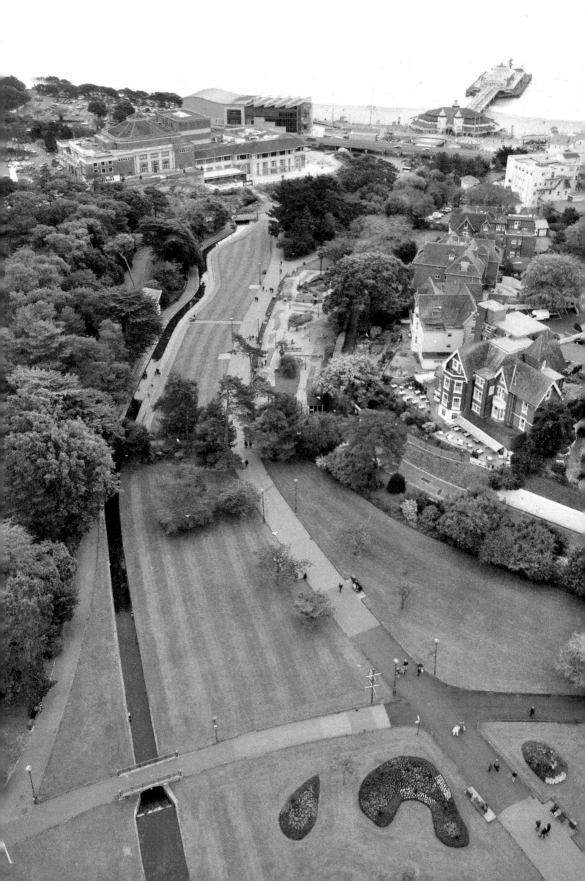

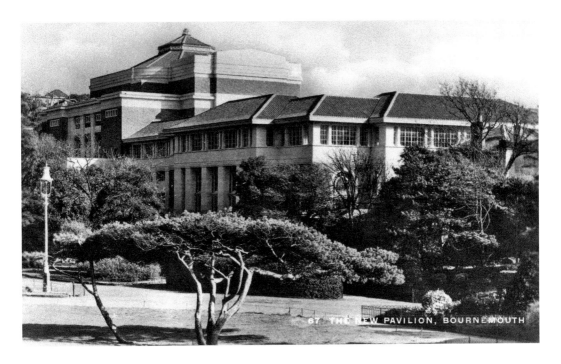

Bournemouth Pavilion and Lower Gardens

The aerial view, opposite, shows the position of the Pavilion backing on to the Pier Approach, with the swathe of green of the Lower Gardens and the River Bourne leading down from the beach to the Square. Built in the 1920s, the Pavilion is the epitome of Bournemouth's municipal architecture with a strong Deco influence and a pleasing blend of red brick and white Portland stone. From this angle, *below*, the building is little changed and in the bright sunshine it looks hopelessly like a picture postcard even now.

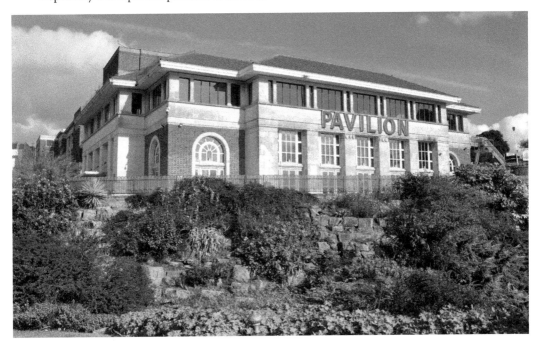

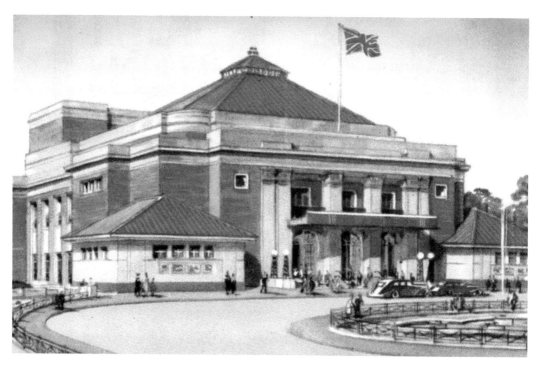

Bournemouth Pavilion

The front entrance to the Pavilion on Westover Road in an illustration taken from the programme cover for a 1961 show, *Wildest Dreams*. The building was designed primarily as a concert venue and the stage facilities were improved in 1933 to allow for large-scale theatre productions. It has changed little externally apart from the vertical extension above the stage and two additional storeys added to the front corners in the 1950s.

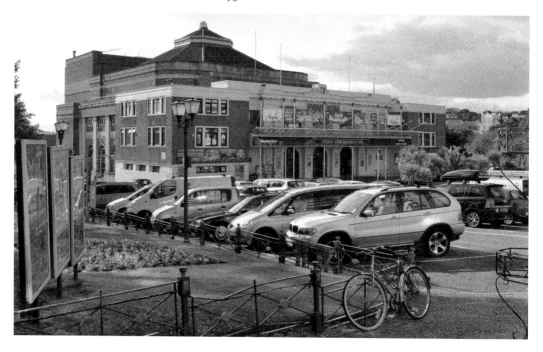

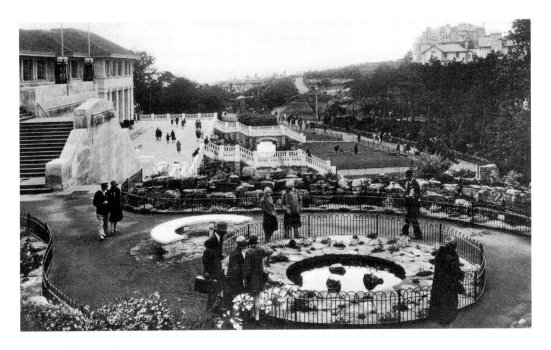

Pavilion Gardens

The pond has gone but otherwise the Pavilion Gardens are unchanged. The building itself became Grade II listed in 1998, thus safeguarding the future of the structure, but the role of the Pavilion is in question, especially now that Bournemouth has the nearby and much bigger Bournemouth International Centre for concerts and events. Both venues are owned and managed by Bournemouth Borough Council. In addition to the auditorium the Pavilion also has a ballroom and restaurant facilities.

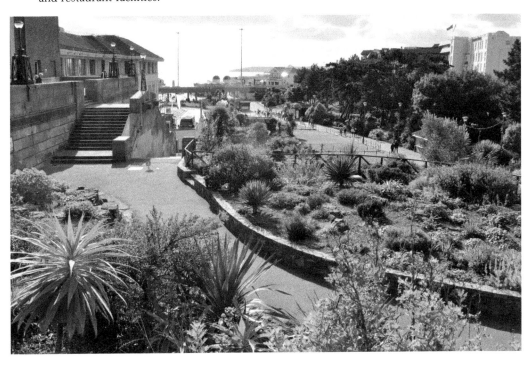

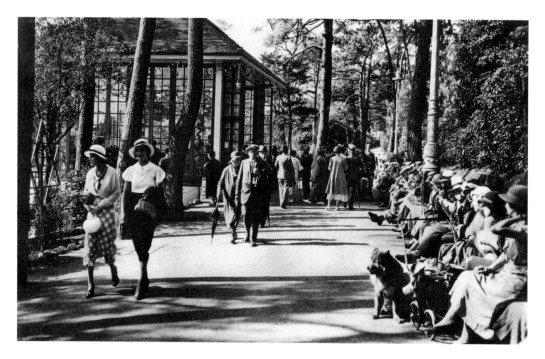

The Pine Walk, Lower Gardens

This sheltered path among the pine trees along the hillside on the eastern side of the Lower Gardens was originally known as Invalid's Walk when the seaside was the place to visit for your health, although that name has fallen out of favour and it is now known as the Pine Walk. It is a popular spot for people who want to sit on a bench and watch the world go by. Some of the mature pines have gone, although the one nearest to the back of the bandstand still remains.

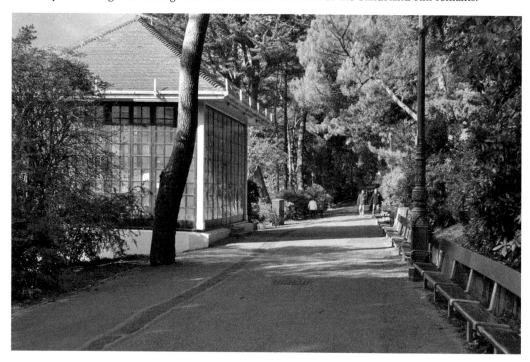

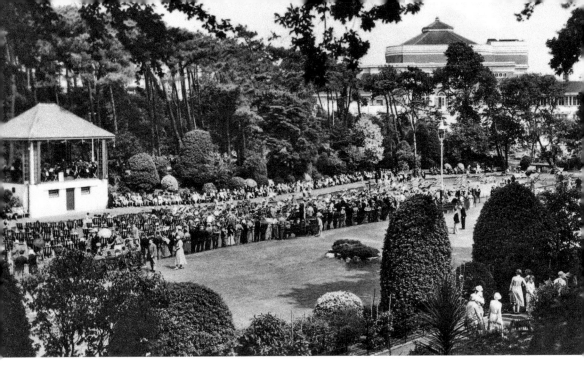

Bandstand and Lower Gardens

The Bourne, which gives Bournemouth its name, runs as little more than a stream in front of the bandstand, seen here from the other side of the Lower Gardens. For generations of young children it has been a popular place to go paddling. The top of the Pavilion pokes up above the trees on the other side of the gardens. Its 'fly' tower was made higher to accommodate theatrical scenery.

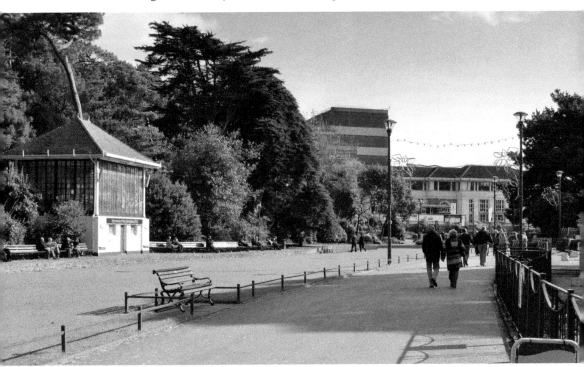

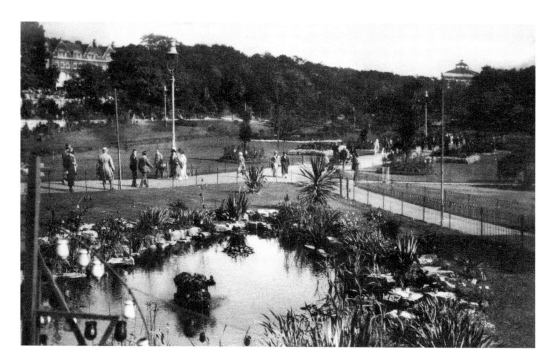

Lower Gardens

The fields around the Bourne stream were drained in the 1840s and as the town grew in popularity a strip of land extending on either side of the stream was planted with shrubberies and laid out as a series of pathways to create what became the Pleasure Gardens. These stretch from the beach up to the Square, the first crossing point over the Bourne, and continue on the northern side. In this view the pond has hardly changed, except that the plants and trees have grown.

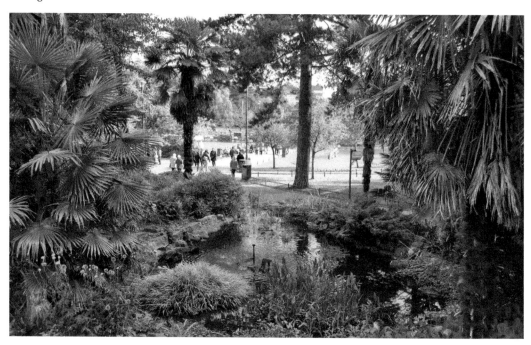

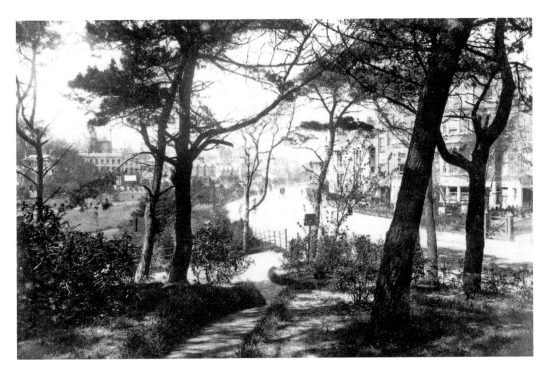

Bournemouth's Pines

Bournemouth is known for its pine trees. Originally this area of the coast had been covered by heathland, and in 1812 the first residents, a retired army officer Lewis Tregonwell and his wife, together with Sir George Ivison Tapps, began developing the land as a resort and this included planting pine trees to create sheltered walks to the beach. This is the path from the Lower Gardens up to Gervis Place, between Westover Road and the Square.

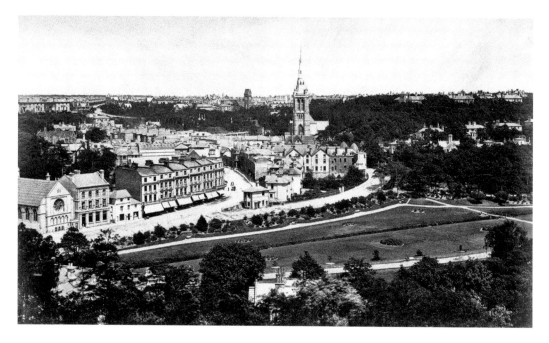

Lower Gardens and Gervis Place

Two old photographs, one is very early from *c.* 1885, looking across the Lower Gardens towards Southbourne Terrace and the bottom of Old Christchurch Road. (*Bmth200*) The terrace is seen in both pictures, as is the tall steeple of St Peters, but by the time of the later 1950s photograph the bigger shops including Plummers are evident in Old Christchurch Road. Note too how the gardens have matured. The Square is just off camera to the left-hand side.

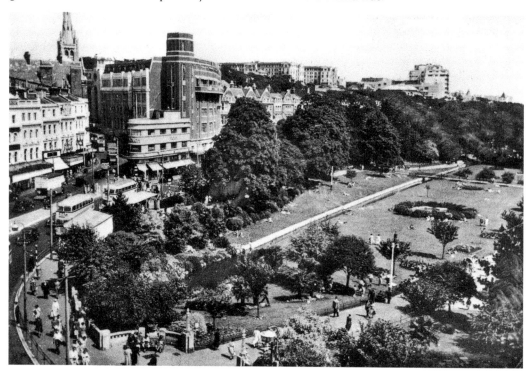

The Square

Looking into the Square from a position between the Lower Gardens and W. H. Smith. This *c.* 1882 photo shows just a handful of horse-drawn vehicles in front of the assorted shops on the corner of Commercial Road, including the Bournemouth & Stow Vale Dairy, Duncan Chemists and a sign announcing 'Pianofortes for Hire'. (*Bmth200*) This corner is now occupied by the Debenhams building, although much of the view is obscured by the pine trees on the edge of the Lower Gardens. The Square ceased to be a roundabout when it was pedestrianised in 2000.

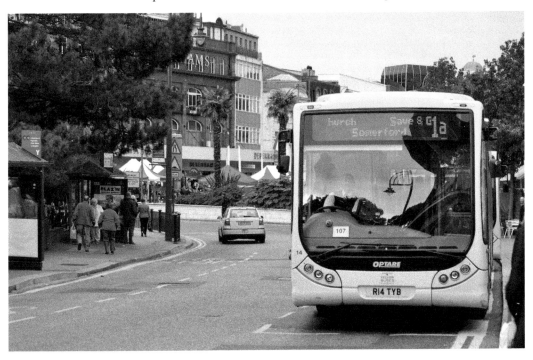

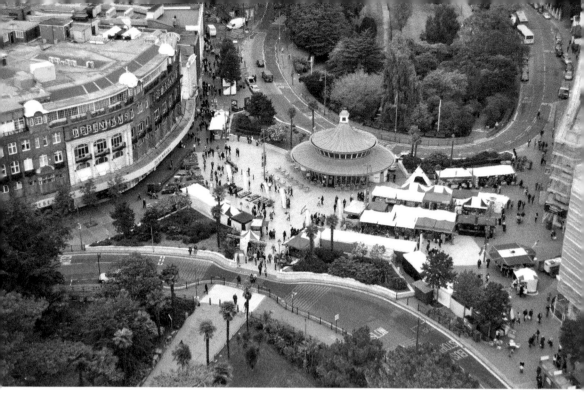

The Square and Upper Gardens

The Square began as the crossing point over the Bourne stream. Later on it became the tram centre, then a roundabout for many years and more recently it has become part of the extended pedestrian precinct. The building in the middle, the Obscura Café, is capped by the old clock and should incorporate a working camera obscura. The Square separates the Lower Pleasure Gardens from the Central or Upper Gardens, *below*.

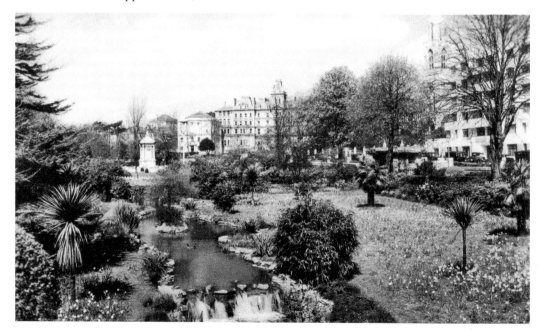

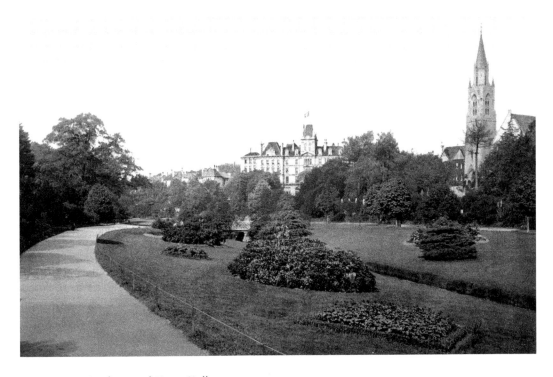

Upper Gardens and Town Hall

This is one of those rare instances when the two photographers separated in time by more than a century are almost identical. The view of the Upper Gardens, sometimes referred to as the Central Gardens at this point, with the town hall and, to the right, the spire of Richmond Hill St Andrew's United Reformed church. The new image includes a couple of buses of course, plus the war memorial, although this is obscured by the mature trees.

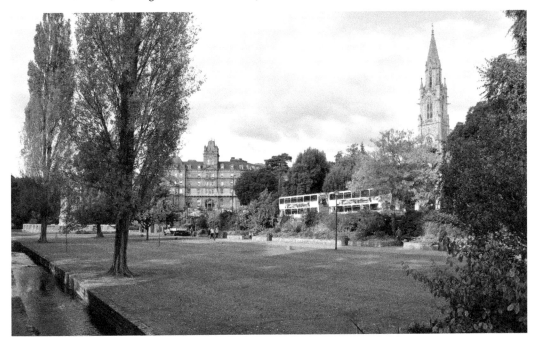

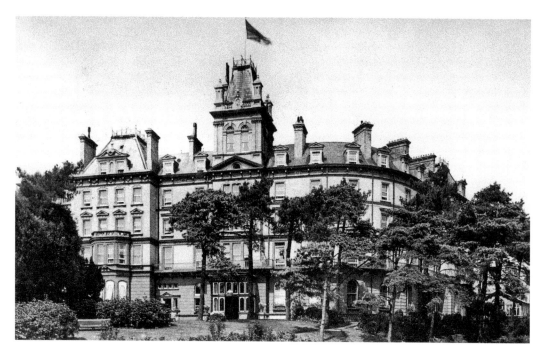

Bournemouth Town Hall

Overlooking the Upper Gardens, the imposing town hall building started off in 1881 as a sumptuous health spa, the Mont Dore Hotel, where the guests could benefit from hot and cold sea water baths. Requisitioned by the War Office in 1914, it served as a military hospital for a while until it became the town hall in 1921. The steep château-style roof capping the central tower is a typical piece of Victorian design.

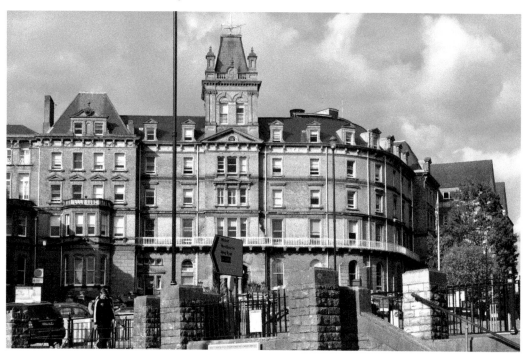

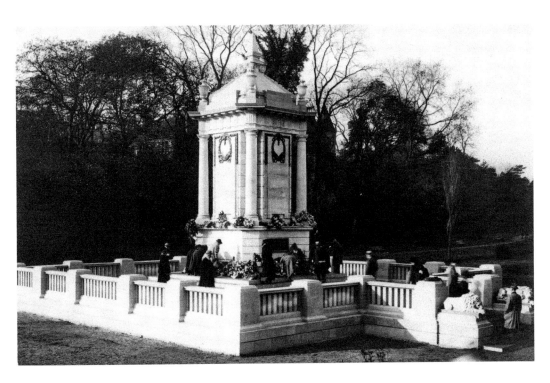

The War Memorial

Bournemouth's war memorial, designed by borough deputy architect E. A. Shervey, was unveiled on Remembrance Day, 1922, by the Lord Lieutenant of Hampshire. This striking monument in white stone commemorated the fallen of the First World War and, as was customary, the names of those who died in the Second World War were later added to it. (*CMcC*)

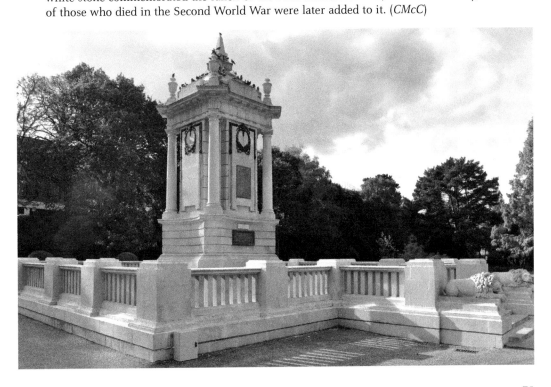

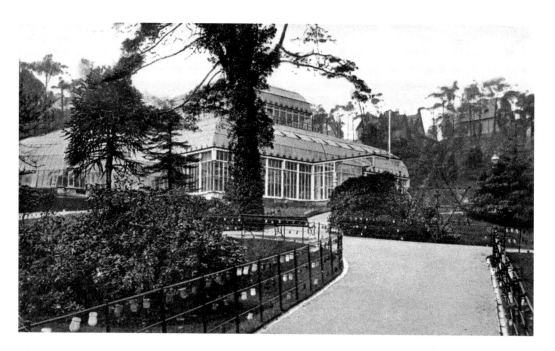

The Winter Gardens

The gardens, situated between Exeter Road and Priory Road, were laid out in 1874 at about the same time as the town's main pleasure gardens. The conservatory style building was completed the following year and put to a variety of uses including concert venue. In 1937 a brick-built building was constructed on the site as an indoor sports facility. It was later converted into a concert venue and during the 1960s and 1970s it attracted many high profile bands including The Beatles and Led Zeppelin. In 2007 permission was granted for demolition with a view to redevelopment, possibly for hotel/apartments with mutiplex cinema and restaurants.

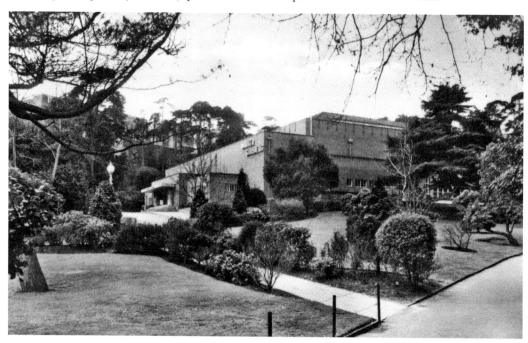

The Square and Richmond Hill

Looking across from Exeter Road towards Richmond Hill, *c.* 1905. On the right-hand side of the hill the Hotel Empress stands on the corner with the Central Hotel and Punshon Methodist church behind. The white building on the left is Hankinson's office for Royal Insurance. In the later view from around 1950 this building has been replaced by shops, including Burtons, and apartments, while the ground floor of the Hotel Empress houses a branch of the National Provincial Bank. By this time the Square has its famous clock tower, but notice the missing spire on the war-damaged church. The delivery van in the foreground is for Advance Linen Services.

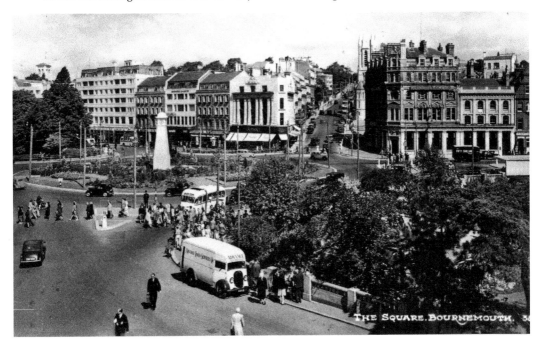

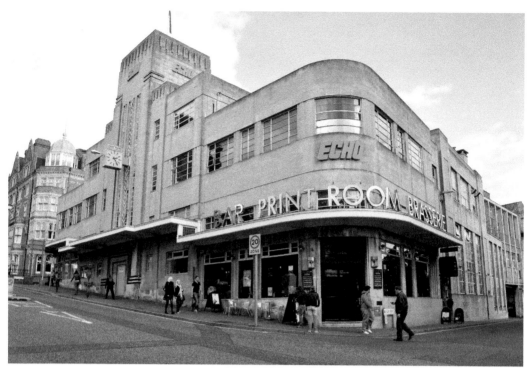

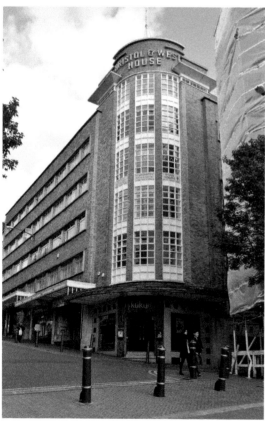

Richmond Hill

Bournemouth's local newspaper, the *Daily Echo*, began publication in 1900. Its landmark offices were designed by Seal and Hardy in 1932 and have survived as one of the town's most notable Art Deco buildings with its fabulous period detailing including the central tower, streamlined corners and metal-framed windows. Just down from the *Echo* building is a fine example of the Deco-inspired Moderne style, albeit post-war and more understated. Bristol & West House is named after the original occupants and the curved tower/corner at the lower part of this steep hill looks so modern that it is generally overlooked in favour of its showier near-neighbour. It was built on the site of the Empress Hotel which was damaged during the war.

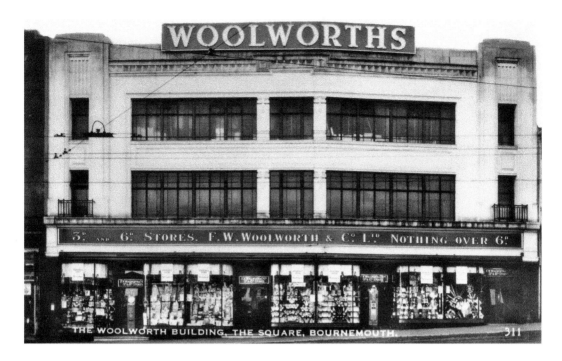

Woolies on the Square

In its heyday the F. W. Woolworths store, universally referred to as 'Woolies', was the focal point of Bournemouth Square for many people. It was said that a town without a Woolies wasn't a town at all. The sign in the old photograph sums it up, '2*d* and 6*d* Store. Nothing over 6*d*'. It sold every manner of household goods and a lot more besides, but in recent decades the Woolies way of shopping became old hat and the Bournemouth branch closed in 1982. Alas the original Deco-influenced façade has been blanked out and the premises are now a branch of the Boots.

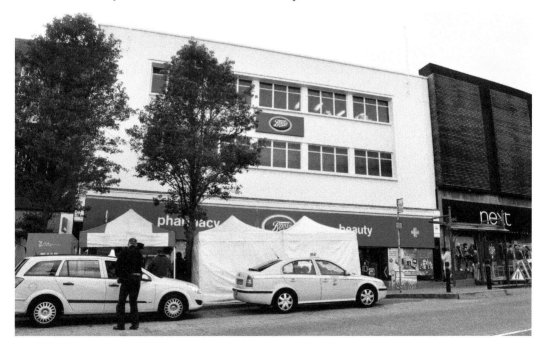

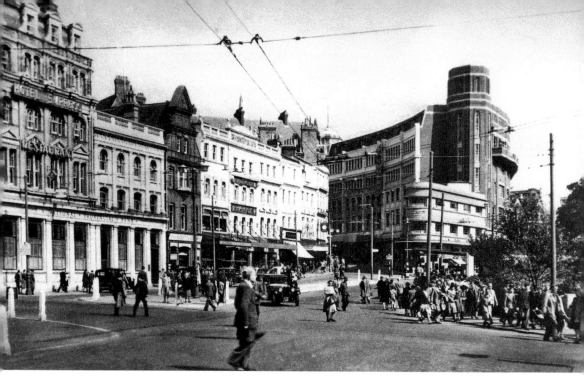

Old Christchurch Road from the Square

Looking east from near the bottom of Richmond Hill with the distinctive hexagonal tower – yet more Deco/Moderne – of the Plummers fashion store looming above Westover Road and the Lower Gardens. The sandstone building squeezed into the corner is the former Dolcis shoe shop, now T-Mobile – see page 93. On the left is the Hotel Empress with bank on ground floor, still a bank, and beyond that is W. H. Smith. Note the overhead lines for the trolleybuses in the 1950s photo. This section of Old Christchurch Road is now pedestrianised.

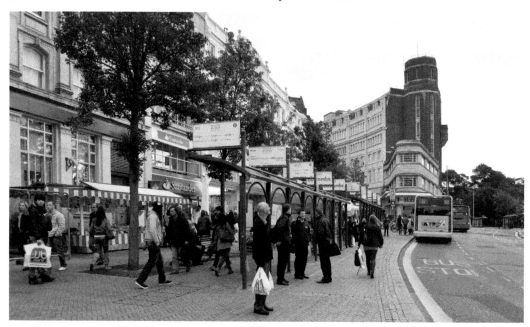

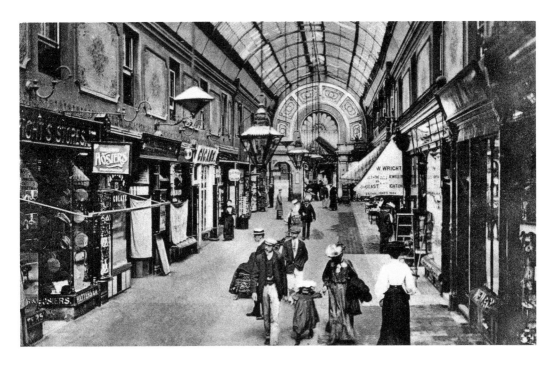

The Gervis Arcade

One of Bournemouth's earliest purpose-built shopping facilities, the Arcade was built in the 1860s and was originally named after its founder as the Gervis Arcade. It runs between Old Christchurch Road and Gervis Place. This 1910 postcard shows a number of retailers, including jewellers, hosier, cigar seller and a Goss china shop. Nowadays it is the domain of the familiar big high street brands including Waterstones and the House of Fraser. Bournemouth has another two Victorian arcades, at Westbourne and Boscombe – see page 75.

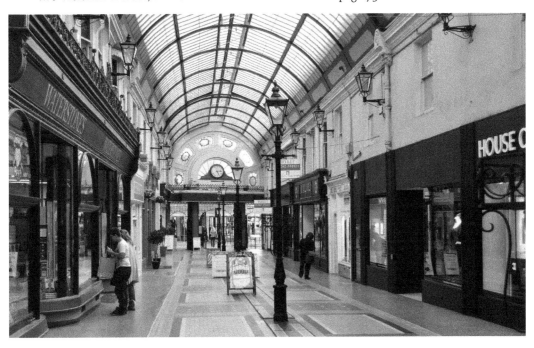

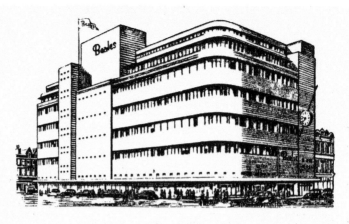
Beales of Bournemouth

Bournemouth's most famous department store was established in 1881 as The Fancy Fair by John Elm Beale, a one-time mayor of the town. The building at the lower end of Old Christchurch Road is a marvellous example of late Deco-inspired Moderne architecture, although the full view portrayed in the 1961 advert is obscured by the surrounding buildings. Bucking the trend for department stores, the Beales company has gone from strength to strength, acquiring an extensive list of other department stores all over the country as well as establishing a strong online retail outlet.

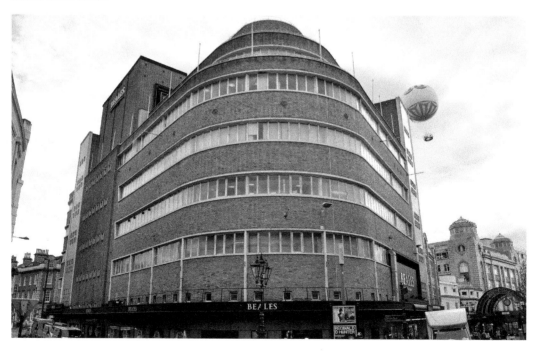

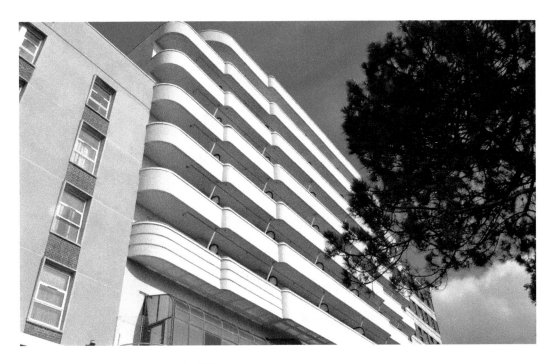

Bournemouth's Art Deco buildings

A seaside town is the ideal setting for the strong lines and colours of Art Deco and Moderne architecture and Bournemouth has a number of magnificent survivors. The horizontal lines of the hotel balconies in Westover Road, now a Premier Inn, overlook the Pavilion and the seafront, while the 1933 Gas & Water Company showroom in Boscombe encompasses all the essential elements of the style with its streamline curves, strong horizontal elements and the staircase tower with corner windows. Shame about the telephone masts.

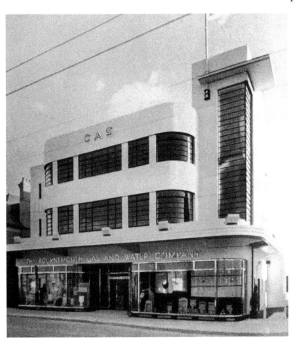
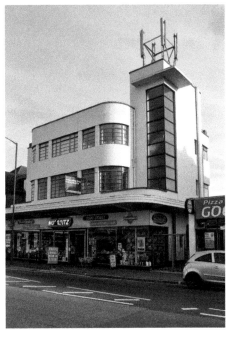

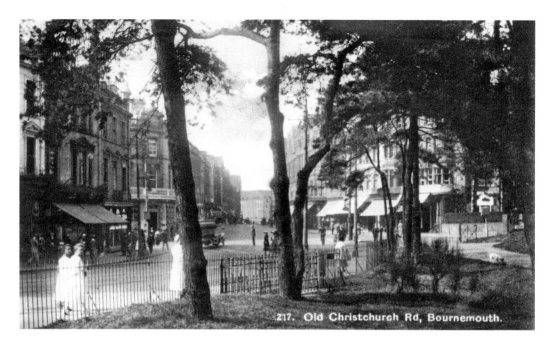

217. Old Christchurch Rd, Bournemouth.

Dean Park and Old Christchurch Road

The view from the bottom of Dean Park, also known as Horseshoe Common because of its shape, looking down Old Christchurch Road towards the centre of town has not changed that much. The railings have gone, a common enough feature throughout the country when they were removed in the wartime effort to salvage metal, but the forked tree in the centre of the old postcard image is the same one on the left of the modern photograph. The corner of Fir Vale Road can be seen branching off to the left – see opposite.

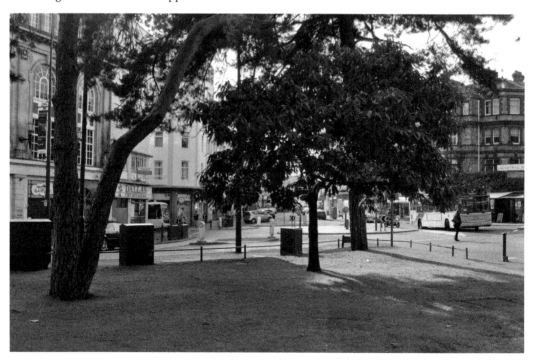

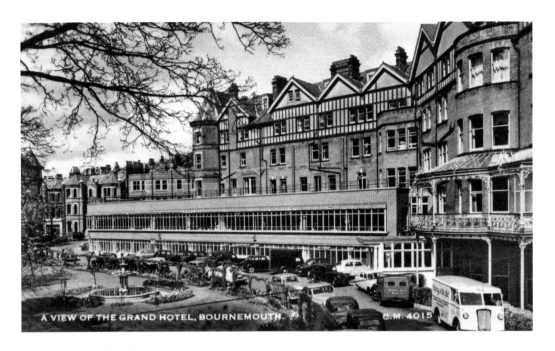

A VIEW OF THE GRAND HOTEL, BOURNEMOUTH. C.M. 4015

The Grand Hotel

Bournemouth's bigger hotels have experienced mixed fortunes over the years. Some have survived while others disappeared without trace. The Grand Hotel on Fir Vale Road was a huge establishment as evident from this late 1950s photograph. Note the gardens and, on the right, the delivery vans for Bournemouth Markets and Corry & Co, Florists. However, the Grand has gone, demolished in 1962, and this area of Fir Vale Road just off Old Christchurch Road is occupied by office buildings and the ubiquitous nightclub. The Grand Hotel Bournemouth is now located in Swanage.

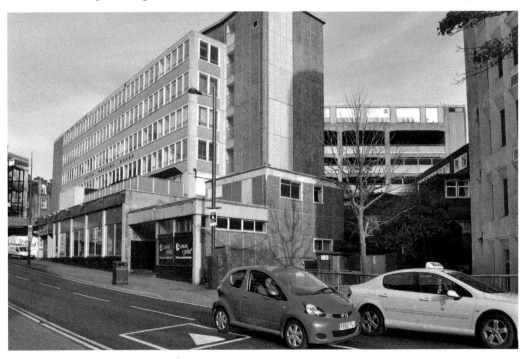

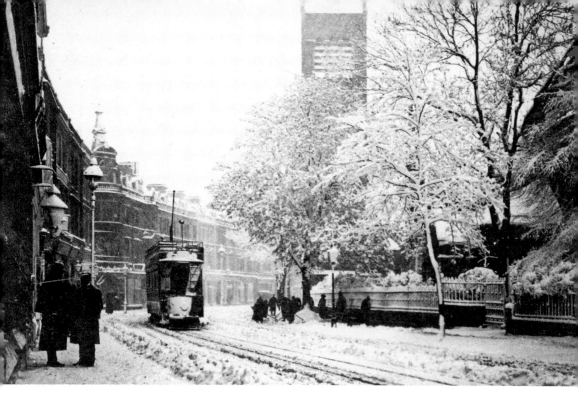

Old Christchurch Road

One of the town's main arteries, Old Christchurch Road, runs up from the Square all the way to The Lansdowne. The road from The Lansdowne to Boscombe is Christchurch Road. In this 1903 wintry scene a lone tram braves the snows as it passes the tall brick-built tower of Holy Trinity Church. The church was built in the Romanesque style in 1869 and the tower was a later addition. Both have gone now, but the buildings on the opposite side of the road, on the corner of Glen Fern Road, still remain. (*CMcC*)

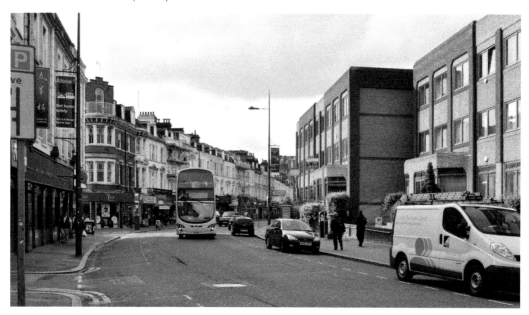

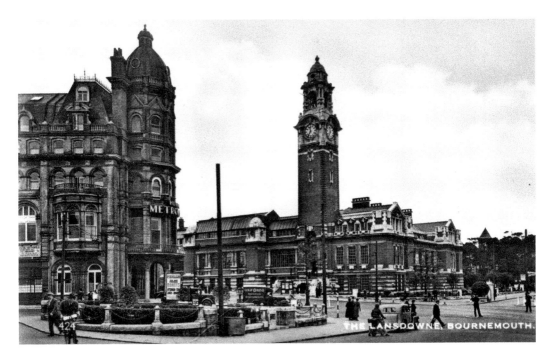

Bournemouth Municipal College on The Lansdowne

Opened in 1915 the Bournemouth Municipal College building on The Lansdowne, with its tall clock tower, has become a major landmark within the town. It incorporated a public library until fairly recently and the extended college complex is now part of the Bournemouth and Poole College of Further Education. In the earlier image the old Metropole Hotel stands on the corner of Christchurch Road and Holdenhurst Road – see overleaf.

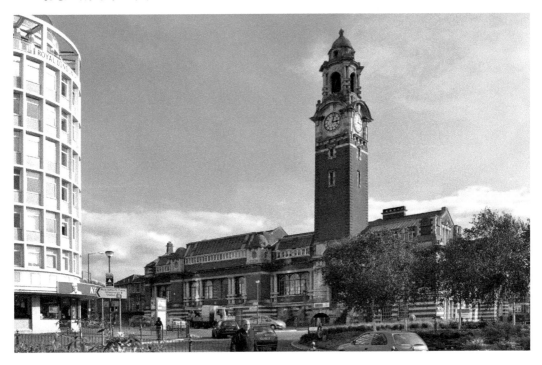

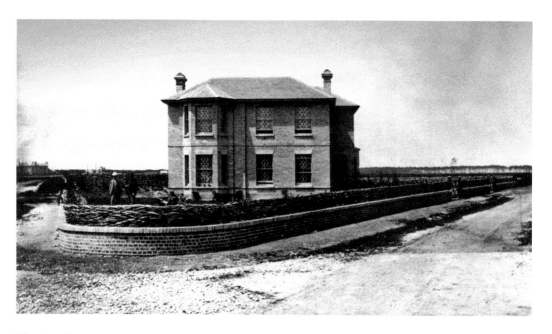

The Lansdowne

Back in 1875 Lansdowne House was just about the only building. It was situated on the corner of Lansdowne Road and Madeira Road, opposite where the main police station was built. There is a Co-op on this spot now and the police station has closed with a new one built on the other side of Madeira Road. (*Bmth200*) The photograph, *below*, shows the modern building that replaced the Metropole Hotel, which was bombed during the war. There used to be a Fortes coffee shop on the ground floor and in the winter the cold wind would howl around this corner.

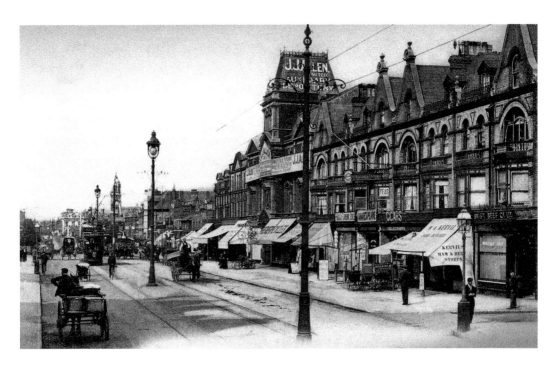

Holdenhurst Road

This long road runs from The Lansdowne north-east across the town, past Central Station. Like many of Bournemouth's main streets it used to be packed with small shops, but in recent decades this section between the railway station and The Lansdowne has seen several new commercial office developments popping up. This view shows the corner of Holdenhurst Road and Collands Road with the clock tower of the East Cliff Congregational church, now the East Cliff United Reformed church, visible in the distance.

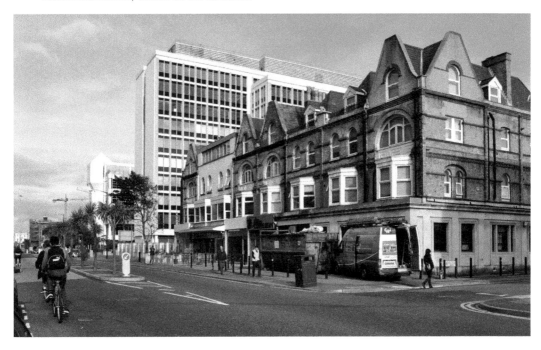

Boscombe Chic

It was once said that 'A seaside without a pier is like a pig without ears'. Bournemouth could be said to have two piers for just a couple of miles to the east of the main one there is Boscombe Pier. Regarded as a suburb of Bournemouth nowadays, Boscombe began life as an independent settlement separated from its neighbour by wood and moorland. From the mid-nineteenth century it became popular among the wealthier Victorians as a location for their marine villas. The notion of a seaside holiday was closely linked to the healing qualities of taking the air and bathing in the sea, and mineral water found in the natural springs at the mouth of Boscombe Chine was exploited to promote the village as a spa. This was partly in response to the desire of the inhabitants to differentiate it from its bigger neighbour, but in 1876 they lost the battle and Boscombe was incorporated within the boundaries of Bournemouth.

Boscombe got its pier in 1889. The original was 600 feet long, built in a series of 40-foot wrought-iron spans with a landing stage on either side for steamers to dock. It became the natural focal point of the Boscombe seafront, although by the mid-twentieth century it had fallen into disrepair and during the Second World War it had been partially dismantled to prevent use by enemy invaders. In the 1950s the seaside needed a revival and Boscombe pier was rebuilt in a thoroughly modern style in concrete. A futuristic entrance building, designed by the borough architect John Burton, summed up the spirit of the times with a roof shaped like an aircraft wing, and the Mermaid Theatre was added to the pier head to cater for the roller skating craze. Alas, fashion is fickle and the pier's popularity faded. The Mermaid closed in 1989 and the entrance building became dilapidated. On the face of it Boscombe had lost out to the more commercial offerings of Bournemouth, although ironically this proved to be its saving grace as it began to draw in a new type of visitor more interested in surfing than the conventional seaside attractions. Coming full circle, the retro 1950s architecture has become incredibly fashionable and a major renovation of the pier and entrance building has been completed. To generate more consistent surfing conditions, an artificial reef was constructed to the east of the pier in 2009, although this has since suffered a few problems, and nearby the double-decker block of beach huts has been turned into expensive 'surf pods'. Boscombe is the new seaside chic.

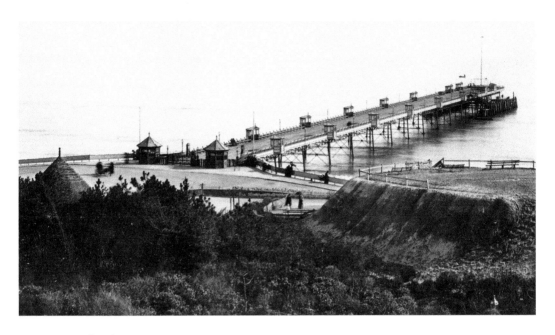

Boscombe Pier

A pier for Boscombe was first proposed in 1884 and was opened on 29 July 1889 by the Duke of Argyll. Constructed in wrought iron it was 600 feet long overall, including the pier head of 120 feet, which had landing stages for the excursion steamers as shown *above, c.* 1890. (*Bmth200*) During the Second World War the pier was partially dismantled to prevent it being useful to enemy invaders, then rebuilt in the 1950s using reinforced concrete to a modern design by the borough's architect John Burton. The Mermaid Theatre opened on the pier head in 1962 as a roller-skating rink, but after falling into decline it was closed in 1989 and later demolished. This has restored something of the pier's original character.

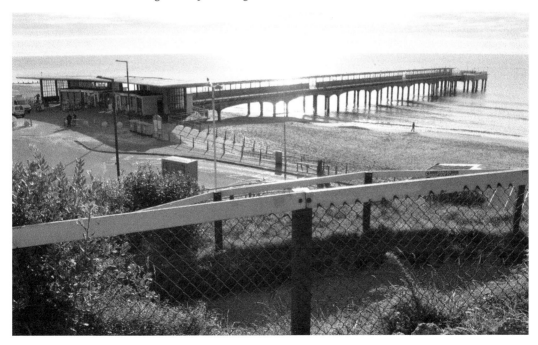

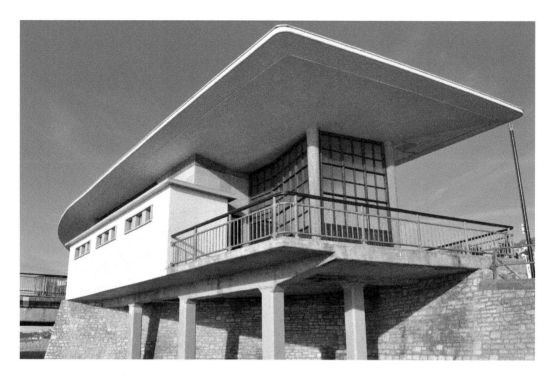

Pier Entrance Building

The entrance building to Boscombe Pier is often described as having the sweep of an aircraft's wing, although it also resembles an oversized 1950s coffee table. Either way this form of 'Beach Deco' fell out of fashion for a while and yet it now resonates with modern tastes for retro-Moderne architecture and has been restored to its former glory as the centrepiece to the Boscombe Spa regeneration plan.

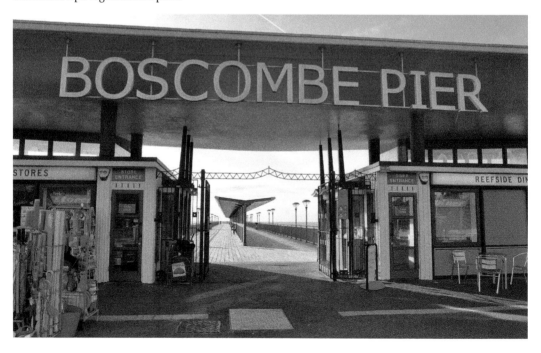

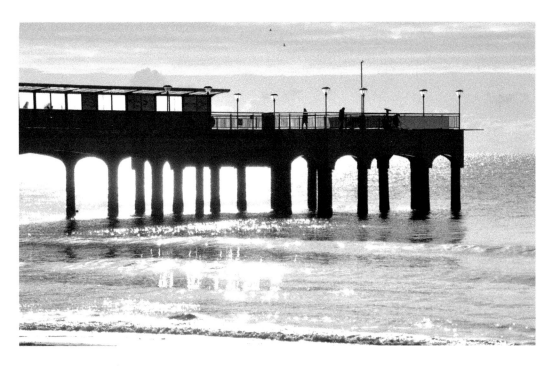

Britain's Coolest Pier

With restoration completed in 2008, Boscombe Pier lost its Mermaid Theatre and the gaudier aspects of the seaside to come full circle as a simple platform for those taking a leisurely stroll or going fishing. For several decades the area has attracted a growing band of surfers and an artificial reef, in the form of a giant sand-filled bag, was constructed on the seabed just to the east of the pier. There have been some problems with the reef, but this didn't prevent Boscombe Pier winning the National Piers Society's Pier of the Year Award in 2010 and also being voted as Britain's Coolest Pier by one website.

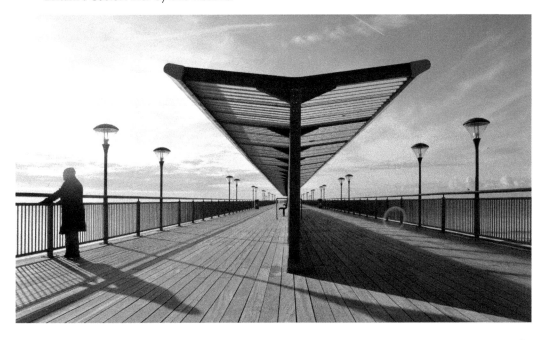

From Beach Huts to Surf Pods

Standing near to Boscombe Pier's entrance on the Undercliff Drive, the 1950s double-decker block of beach huts has been given a thoroughly modern makeover by design gurus Wayne and Geraldine Hemingway, founders of Red or Dead, to become exclusive surf pods complete with individual retro décors and all mod cons. On the west side of the pier this small building on the Promenade, *below*, gives a new take on the traditional bright colours of the seaside.

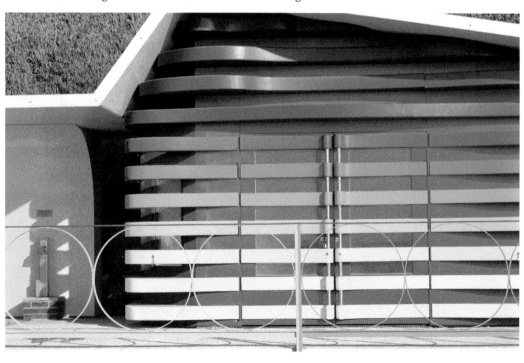

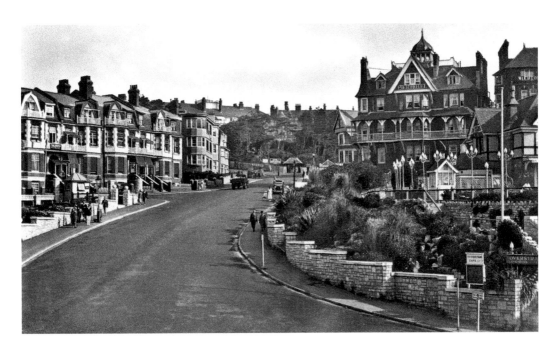

Sea Road

The Edwardian houses on the Undercliff Road to the left have hardly changed since they were built in 1903, but on the other side of Sea Road, to the east and shown on the right in this 1950s view, the old Pier Hotel and Overstrand Café have given way to a modern development of fashionable seaside apartments. Looking out over the sea these are hot property and such homes are attracting a new breed of modern seaside dwellers. Boscombe Chine, leading up to Christchurch Road, is located beyond the end of the older houses to the left of the picture.

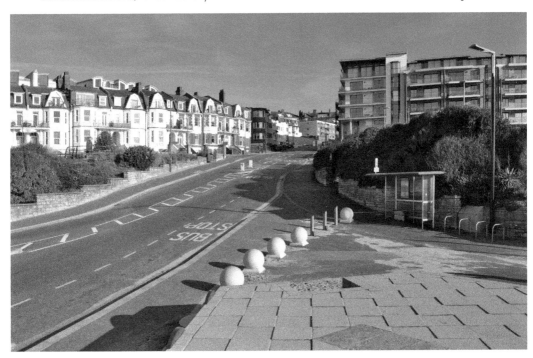

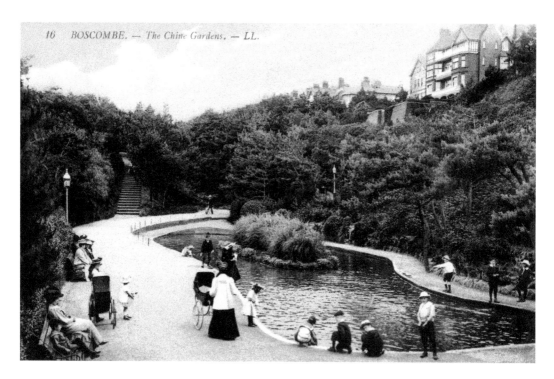

Boscombe Chine

The chine provided a gently inclined pathway from the fashionable parts of central Boscombe down to the seafront. At one time the natural mineral water found in springs near the mouth of the chine was promoted for its health-giving properties. This colour postcard from around 1905 shows the Chine Gardens with a pond for the smartly dressed children. Only a token pond remains and the main area is now laid out as a playground. Some of the old houses overlooking the side of the chine can be seen beyond the trees in both photographs.

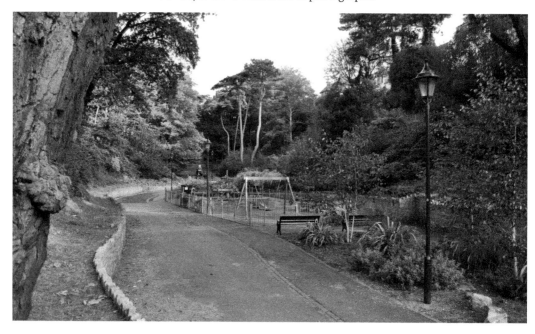

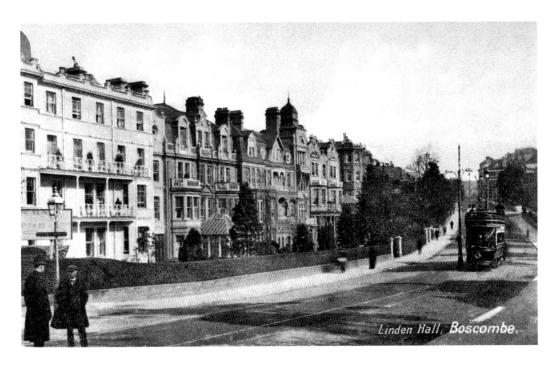

Linden Hall, *Boscombe.*

Chritschurch Road, Boscombe

Looking up the incline of Christchurch Road into Boscombe, with the Linden Hall on the left and the start of the shopping area at the top of the hill on the right. Opened in 1890 as the Linden Vale, it became the Linden Hall Hydropathic Hotel in 1934 with the installation of swimming pools. The hotel closed in 1983 and the building was replaced by new flats. The entrance to the Chine Gardens is to the right of the photographer's position. The trams have gone and, in their place, the yellow buses negotiate a steady stream of traffic on this very busy main road.

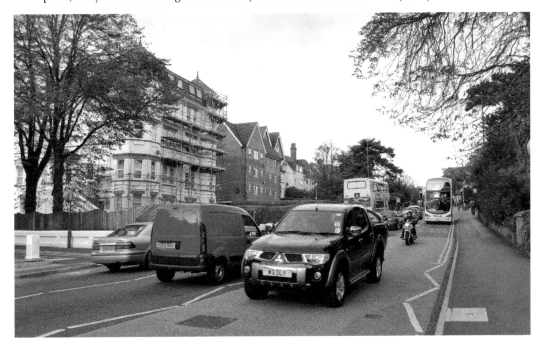

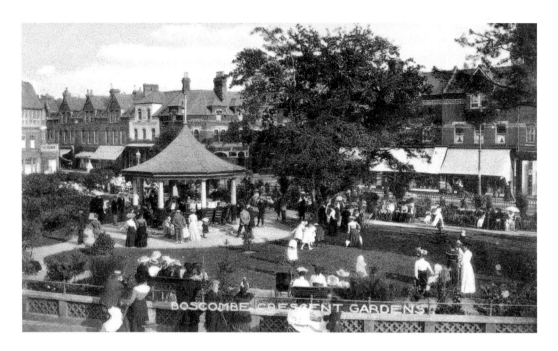

Boscombe Crescent Gardens

Located on the north side of Christchurch Road and once described as the 'gateway' to Boscombe, the Crescent Gardens are a graphic indication of how an area's fortunes can change. In Edwardian times it was a fashionable place where people gathered on a Sunday afternoon to listen to the band. In this old postcard there are several shop signs in the background including Street & Sons Ironmongery and the chemists on the corner of Adeline Road. More recently the Crescent has become run down, but there are plans afoot for a much needed makeover. 100 years or so after the first picture the ironmongers have gone, but the chemist is still there as a Lloyd's Pharmacy.

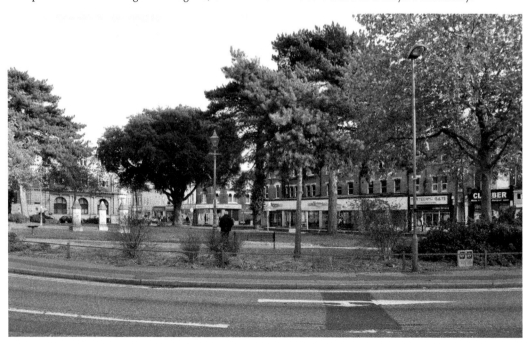

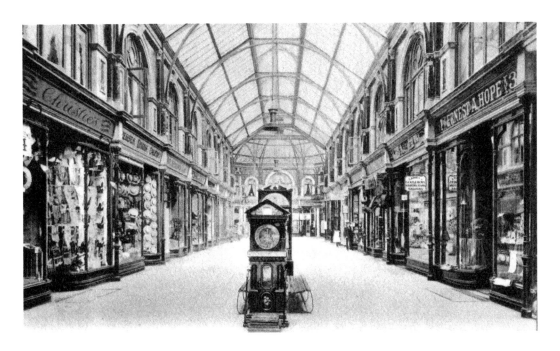

Boscombe's Royal Arcade

Not to be outdone by Bournemouth, Boscombe's fashionable residents could go shopping in their own Royal Arcade. Opened in 1892 it was designed by the architect Archibald Beckett who mounted a one-man campaign to transform Boscombe's commercial centre. He also constructed the Grand Pavilion Theatre, which opened in 1895. Hidden above the adjoining shops the theatre has gone through various name changes since then, including the Hippodrome and the Opera House, and it now serves as an auditorium for the O2 Academy Bournemouth.

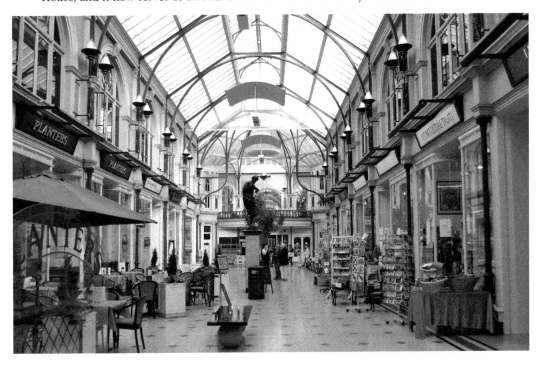

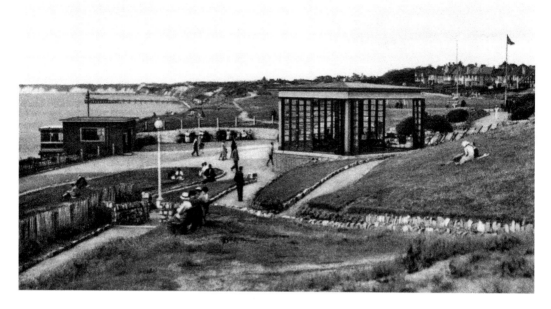

Southbourne Cliffs

Lying between Boscombe and Christchurch, Southbourne is the most easterly suburb of Bournemouth. At one time it had its own pier, 300ft long and constructed in 1888 to handle visiting excursion steamers, but this was demolished in 1909 after being heavily damaged in storms. Southbourne represents a quieter aspect of the seaside and remains popular with tourists keen to escape the busier seafronts of Boscombe or Bournemouth. While the old bandstand may have gone, the lift down to the Promenade and beach still remains operational. There is also a zigzag just out of view further to the left of the picture.

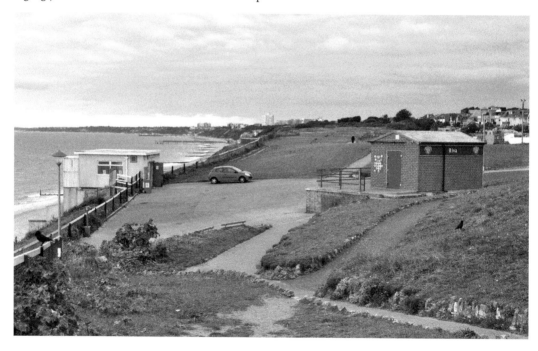

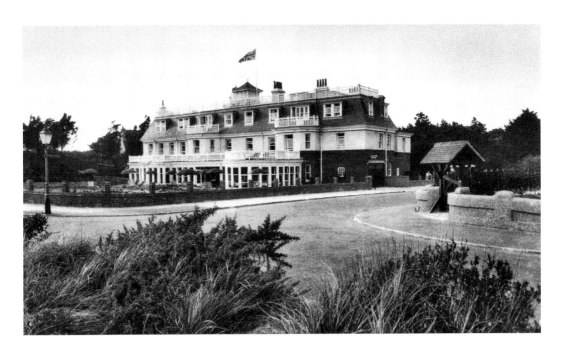

Southbourne

The Southbourne Coast Road running along the clifftop was once full of small hotels and guest houses, such as the Grange Hotel which stood on the corner of Pinecliff Avenue. The site is now occupied by houses and as the price of property near the Bournemouth, Boscombe and Sandbanks seafront continues to soar, quiet Southbourne looks set to experience its own property boom as this area becomes increasingly desirable. Heading eastwards along the coast from Southbourne you come to Hengistbury Head and then the harbour and historic town of Christchurch.

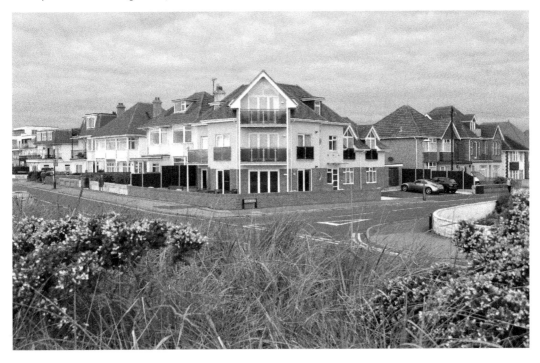

Bournemouth's Transport

During the nineteenth century, the rapid spread of Britain's railway network transformed the lives of millions of people, whether travellers, railway workers, or those whose lives were disrupted by their construction. For Bournemouth and many other seaside towns it brought a period of great prosperity and growth with the arrival of the holidaymaker. Bournemouth's main railway station, located just to the east of the present site, opened on 20 July 1885. Built by the London & South Western Railway it was originally known as Bournemouth East, although when relocated to the other side of the Holdenhurst Road it later became Bournemouth Central. This was a thoroughly confusing name for the newly arrived passengers who found themselves far from the centre of the town or the beaches. The station is on the main line from London Waterloo to Weymouth, and it is now known simply as Bournemouth. The town also has several smaller stations: Boscombe, which later became Pokesdown, and on the western side there are the Branksome and Parkstone stations.

Bournemouth's tramway system opened in 1902 and the first buses were introduced as feeders to the trams just four years later. In 1933 the borough introduced the trolleybuses, on an experimental basis at first, and over the next few years they came to replace the trams. In the post-war years the trolleybuses were gradually superseded by diesel-engine buses with the last one running in 1969. I distinctly remember riding on the yellow trolleybuses as a child. The best bit of any journey was when the arms came off the overhead electric wires at Cemetery Junction, which they often did, and the conductor would jump off to extricate a long bamboo pole from under the bus with which he hooked the arms back into place. The old trams and trolleybuses may have gone, but Bournemouth still has its yellow buses, which were privatised in 1985 and are now operated by the RATP Group. Not all buses are yellow and at one time the apple-green of Hants and Dorset and the red of the Wilts and Dorset companies were also seen in the town, while the main coach operator, Royal Blue, added to this transportation rainbow.

The town has also made its mark on the history of aviation. During the 1910 Bournemouth Centenary Air Meeting the aviator and motoring pioneer, Charles Rolls, became the first victim of powered flight in this country. Nowadays, Bournemouth Airport handles almost a million passengers annually on both domestic and international flights.

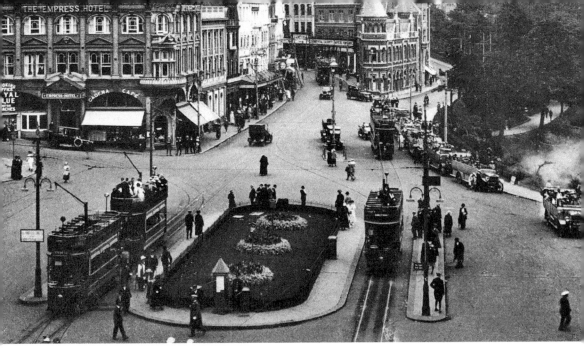

Trams and Trolleybuses

Trams first ran in Bournemouth in 1902 and they continued to operate until the 1930s when they were superseded by the trolleybuses. In the upper photograph from 1925 there is precious little traffic apart from the trams and a row of charabancs lined up beside the Gardens. Note the booking office for Royal Blue Coaches at the bottom of Richmond Hill. Flash forward to 1953, *below*, and the Square has become a circle and the primrose yellow and burgundy trolleybuses are joined by a handful of diesels.

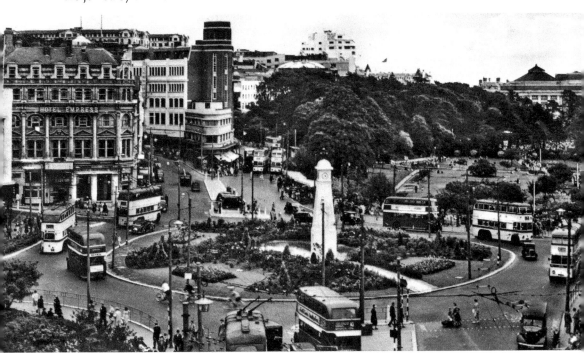

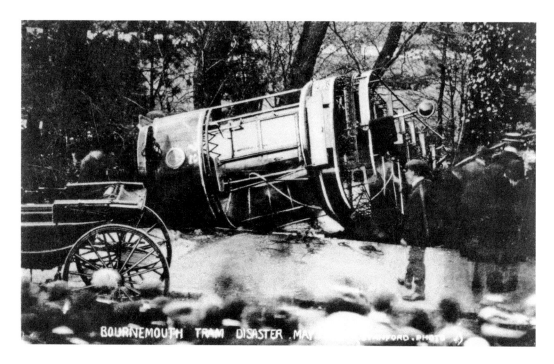

Bournemouth Tram Disaster

On 1 May 1908 a tram travelling down Poole Hill towards the Square suffered brake failure. Travelling much too fast it failed to negotiate the curve at the bottom of Avenue Road and toppled over, falling 20ft down the bank into the Upper Gardens. In Britain's worst tram disaster seven people were killed and another twenty-six injured. Another accident later occurred in Boscombe when an unattended tram ran down a slope onto the beach resulting in two fatalities. Bournemouth's trams were finally withdrawn from service in 1936.

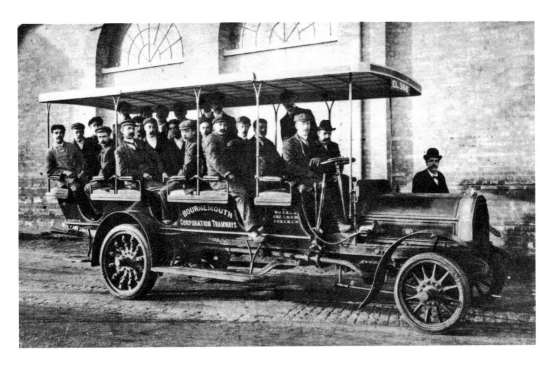

Single-Deckers

Inevitably the area that the trams covered was limited by the extent of their rails and overhead cables, and from 1906 Bournemouth Corporation Tramways operated single-decker motor buses as feeders to the tram network. (*CMcC*) No. 44, *below*, is a marvellous example of a preserved post-war Leyland single-decker in the splendid primrose yellow, which gave the town's buses their distinctive look. (*Helen and Mike Pursey*)

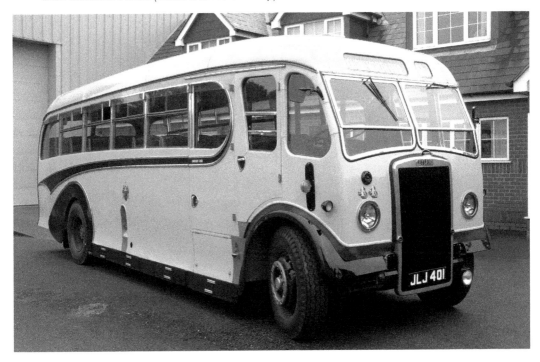

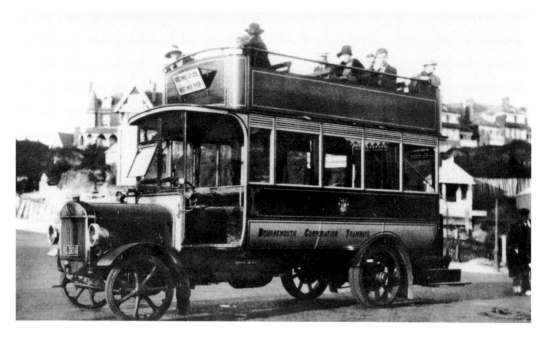

Double-Deckers

A Bournemouth Corporation Tramways double-decker motor bus stopping at the bottom of Sea Road at Boscombe with the Pier Hotel in the background, *c.* 1910. The destination board shows it was operating between Boscombe's Arcade and Pier. Its modern counterpart is HF11 HCP, a Volvo B9TL chassis with Wright Eclipse Gemini 2 body. Operated by Yellow Buses it is shown near the Square with the town hall tower visible in the distance.

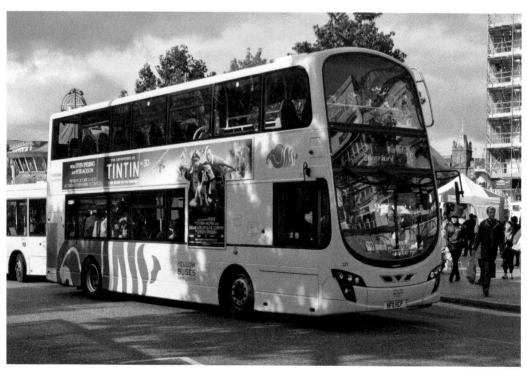

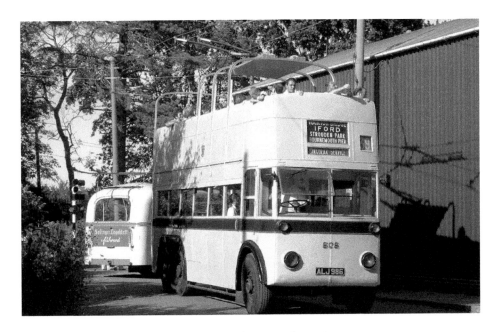

Trolleybuses

Bournemouth's most famous yellow buses were, of course, its trolleybuses. Like the trams these took power from overhead electricity lines but ran on ordinary road wheels. The trolleybuses were introduced in 1933 and replaced the tram network. At its peak the Bournemouth system operated on twenty-two routes with a maximum fleet of 104 buses, including several open-top versions such as the preserved example shown at the East Anglia Transport Museum. Note the web of overhead cables. In 1963 it was decided to replace the trolleybuses with diesel vehicles. This process took place in four stages with the final trolleybuses running on 20 April 1969. (*SP Smiler*)

B.C.T.

BOURNEMOUTH CORPORATION TRANSPORT

TIME TABLE

PRICE SIXPENCE

9th September 1968 until further notice

★ LAST TROLLEYBUS YEAR ★

TROLLEYBUSES WILL BE REPLACED BY MOTOR BUSES IN 1969.
FULL DETAILS OF REMAINING TROLLEYBUS SERVICES ARE SHOWN
ON PAGES 17–20.

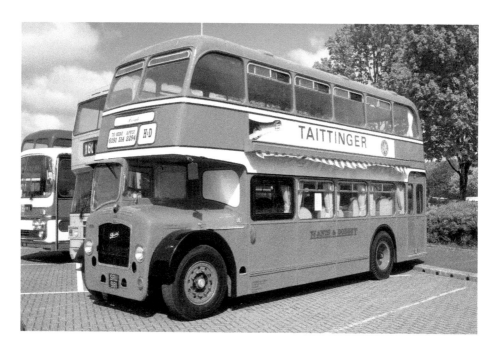

Green and Blue...

Not all buses were yellow and the apple-green Hants & Dorset buses operated services on longer routes. *Above*, is a Bristol Lodekka. (*Ultra 7*) In 1931, H&D opened an imposing two-level bus station on Exeter Road, but this was severely damaged by fire in 1976 and later demolished. Royal Blue Coaches were started by Thomas Elliot in Bournemouth in 1888 and continued until 1973 when they were replaced by National Express. (*Helen and Mike Pursey*)

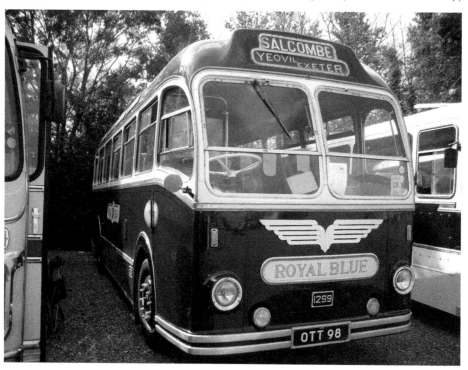

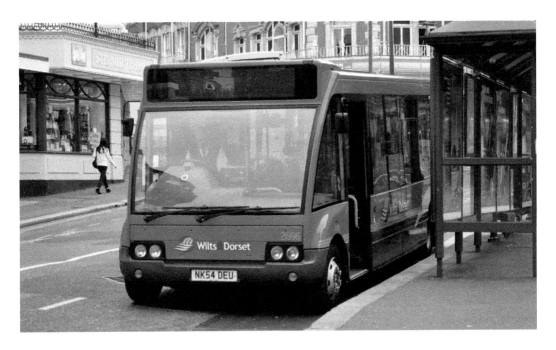

...and Red and Blue

Together with H&D, Wilts & Dorset became state-owned in 1948 and in 1965 the management of the two companies was merged. In 1968 they were subsumed into the National Bus Company and the H&D and W&D brands disappeared. Following the deregulation of the buses W&D re-emerged in 1987 and this single-decker is in the red and blue livery. In December 2004 these were joined by the all-blue 'More' buses operating in Poole and Bournemouth in competition with the yellow ones.

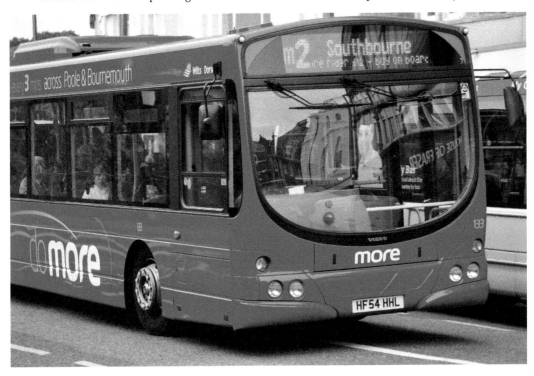

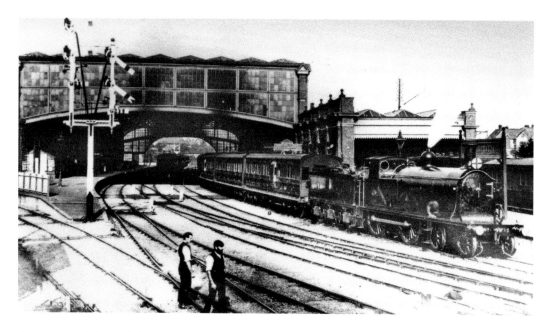

Bournemouth Central Station
The town is located on the main railway line running from Waterloo to Weymouth. Located on Holdenhurst Road, Bournemouth's main station was anything but central when it opened as Bournemouth East in 1885. The present station on the north side of the road was designed by William Jacob, chief engineer of the London & South Western Railway, and it features a wide girder roof shown *above, c.* 1905. This was damaged in the Great Storm of 1987 and refurbished by Railtrack in 2000. Bournemouth's other stations are at Boscombe, which is now known as Pokesdown Station, and to the west there is Branksome and Parkstone. The Central Station was renamed simply as Bournemouth Station in 1967.

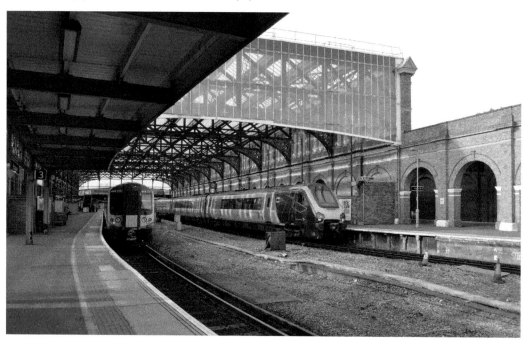

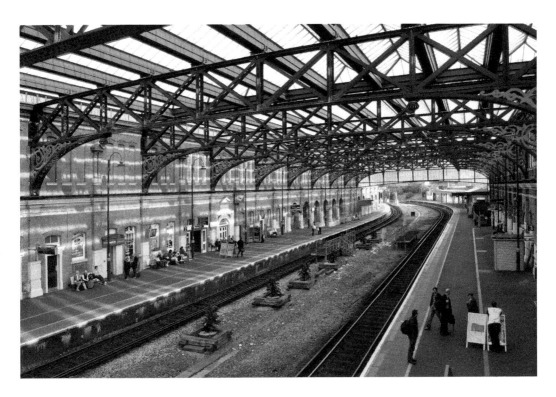

Bournemouth Station

The station has changed little over the years apart from a fully glazed roof, which lets in much more light, and the removal of the central tracks, which ran between the Up and Down lines until the end of steam in 1968. Without these tracks the station seems unnecessarily wide and the rather sad potted palms fail in their bid to conjure up the spirit of the seaside. Until the footbridge was added passengers used an underpass to get from one platform to the other.

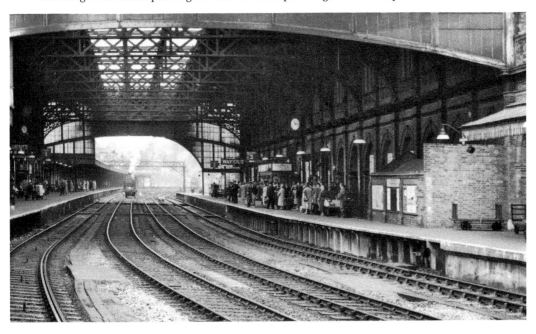

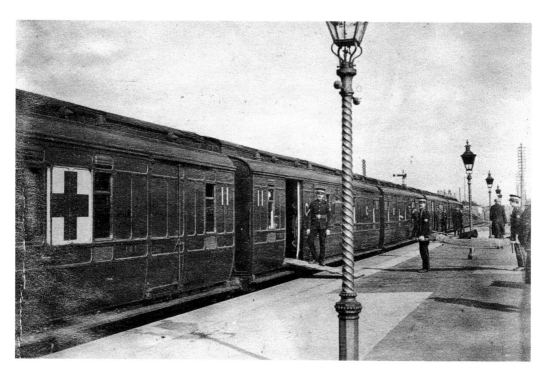

First World War Hospital Train

The First World War recruiting posters had shown a train packed with cheery soldiers above the slogan 'There's Room For You – Enlist Today!' What they didn't publicise were the hundreds of hospital trains, which brought an army of wounded men back to Blighty for treatment. These rare snapshots show Hospital Train, No. 11, arriving at one of the Bournemouth stations. (*CMcC*)

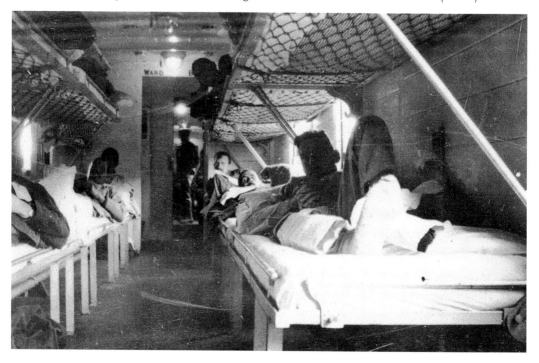

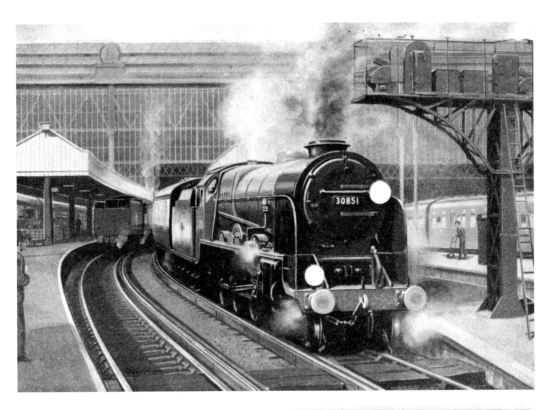

The Sunshine Railway

The railways brought the holidaymakers to the town in droves and the fast mainline services direct from Waterloo made it a popular destination. *Above*, the 30851, *Sir Francis Drake*, a former Lord Nelson class Southern Railway loco departing from Waterloo in British Rail livery in the 1960s. The most famous train to the south was the Bournemouth Belle composed of Pullman stock, which ran between 1931 until nationalisation in 1948 with a wartime break of service. The final Belles in 1967 were hauled by British Rail diesels. The iconic Southern Railway's poster with the small child talking to the loco driver also features Waterloo with its distinctive overhead signal box in the background.

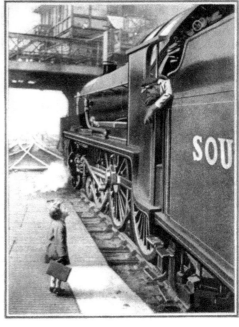

"Yes, I always go South for Sunshine by SOUTHERN"

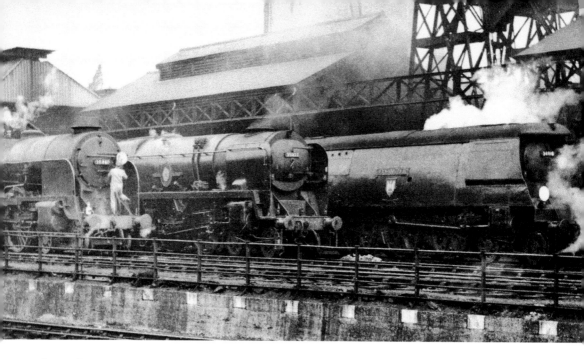

Steam Days

The Bournemouth line had the distinction of being the last one to be operated by steam with the final trains running in August 1968. Photographed in the 1950s, this cluster of locos standing near the sheds includes 30861, the Lord Nelson class *Lord Anson,* which was withdrawn in 1962, 35027 *Port Line*, a Merchant Navy class now preserved on the Bluebell Line, and 34018 *Axminster*, a West Country class Pacific. Below is a classic image of another Lord Nelson class loco, the Southern Railway's 862 *Lord Hollingwood* hauling the Bournemouth Belle's distinctive Pullman coaches.

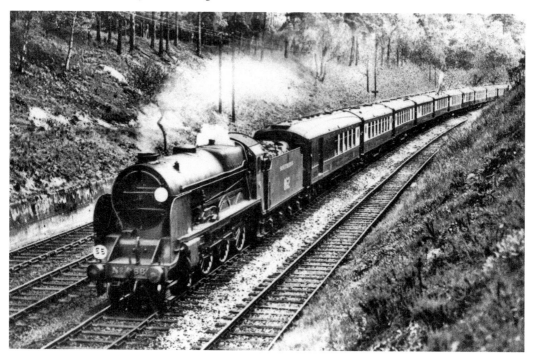

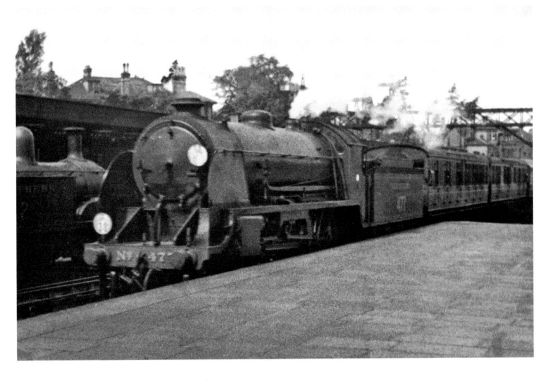

L&SWR Locos at Bournemouth

A pair of former London & South Western Railway locomotives taken into Southern Railway ownership after the 1923 regrouping and photographed at Bournemouth on a sunny afternoon. No. 447, *above*, is an H15 class 4-6-0 mixed traffic loco originally designed by Robert Urie for the LSWR and built in 1924. *Below*, No. 4 is an 0-4-4 tank engine. (*CMcC*)

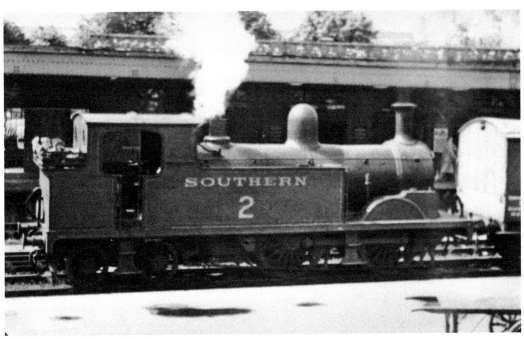

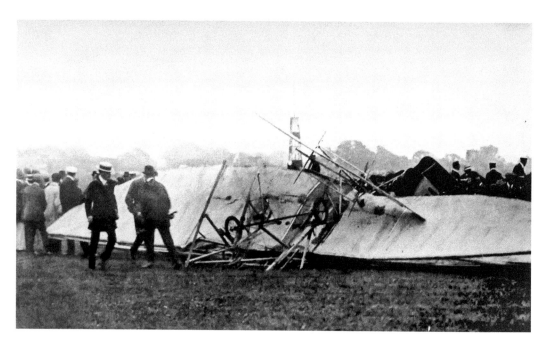

Bournemouth Aviation

On 16 July 1910 the aviator Charles Stewart Rolls became the first Briton to die in an aircraft accident when his Wright Flyer crashed at Hengistbury Airfield near Bournemouth. Rolls was only thirty-two years old and he is perhaps better remembered as one half of the famous Rolls-Royce name. In recent years Bournemouth has hosted a series of spectacular annual air displays along the seafront, but in the summer of 2011 a jet from the Red Arrow display team crashed near the airport killing its pilot. (*BIL*)

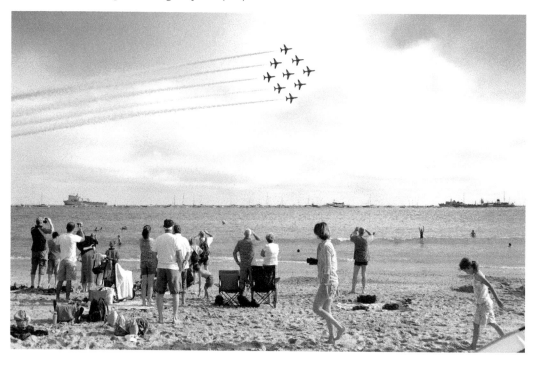

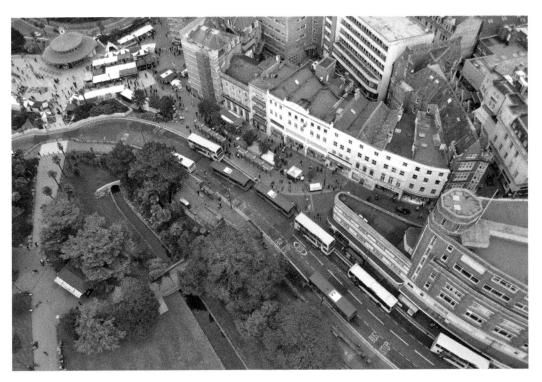

The Bournemouth Eye

Charles Rolls was already an accomplished balloonist before he took up powered flight. The Bournemouth Eye is a helium-filled tethered aerostat, which operates from the Lower Gardens. Similar balloons were enormously popular in the latter half of the nineteenth century and they were reinvented in the 1990s using modern materials and equipment. It can carry up to thirty passengers at a time as it rises to a height of 390 feet, the maximum permitted by the UK's Civil Aviation Authority. The aerial photographs in this book were taken from the balloon. The town also has its own airport, which began life as RAF Hurn back in 1941 and began commercial services in the late 1950s. At its peak Bournemouth International Airport handled over one million passengers a year (2007), but this figure has dropped slightly more recently.

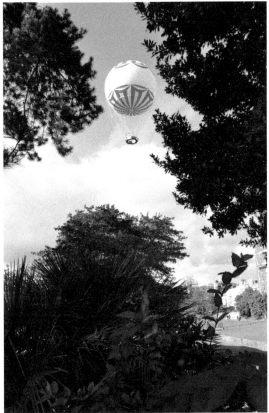

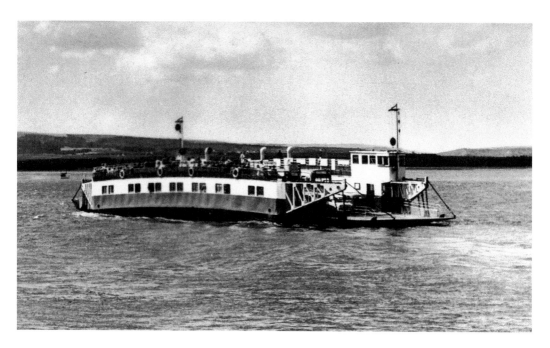

Sandbanks Ferry

Since 1923 the Bournemouth to Swanage Motor Road and Ferry Company has operated the chain ferry between Sandbanks and Studland across the busy stretch of water at the entrance to Poole Harbour. The *Bramble Bush Bay, below,* is their fourth vessel and entered service in 1994. It carries up to forty-eight cars on a nominal twenty-minute frequency, and the ferry crossing saves motorists twenty-five miles on their journey to or from Swanage. At the time of publishing the toll per car was £3.50 for each trip. (*CMcC*)

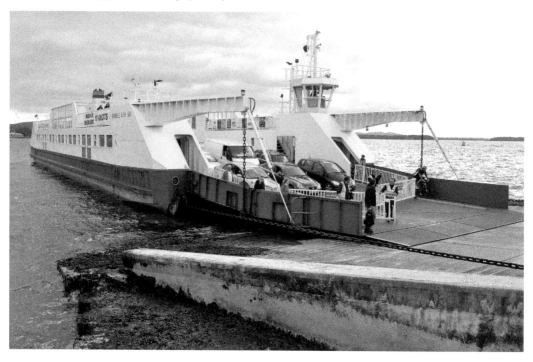

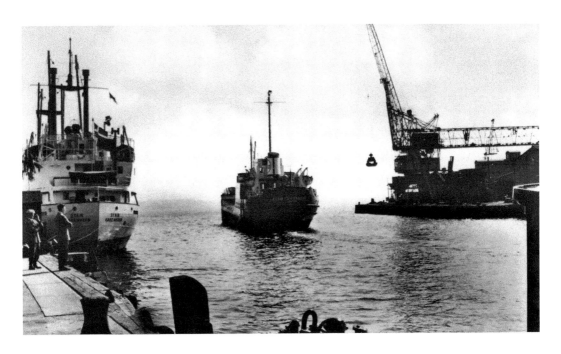

Poole Harbour

This is one of the largest natural harbours in the world and it was once a major commercial port. The photograph, *above*, shows the *Esso Lyndhurst*, a tanker built in 1958 and sold on to a Saudi company in 1980, and the vessel to the left is the Danish *Strib Kobenhavn*. Nowadays, the harbour is used primarily for recreational purposes, although it is still used by some coastal trading vessels and there are regular ferry services. Brittany Ferries operate between Poole and Cherbourg, with Condor Ferries going to the Channel Islands and also to St Malo in Brittany. The *Condor Express* is a fast catamaran built in 1996. (*Arpingstone*)

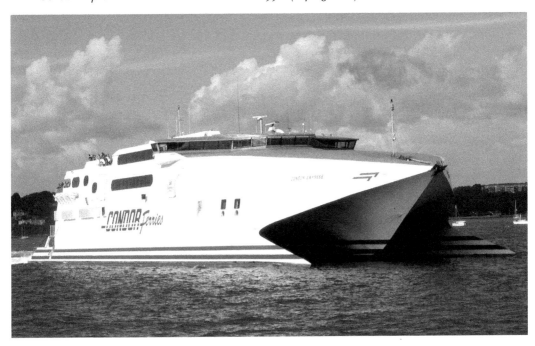

THESE WELL-BUILT SHELTERS COME IN USEFUL ON THE SEA FRONT.
(ANY PORT IN A STORM)
AT BOURNEMOUTH

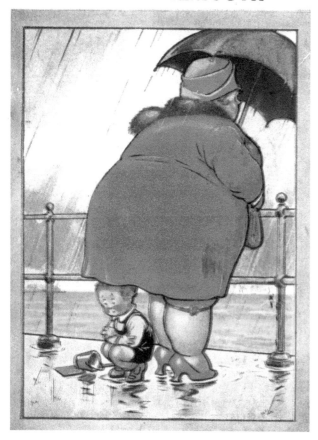

Seaside Humour
Bamforth's postcards were produced by the thousands. Some veered towards the saucy, while many, such as this one, featured variations on the ubiquitous small child and more generously proportioned adult. As was the custom, the name of the appropriate town has been over-printed on to the card. Maybe not politically correct by modern standards, but nonetheless a nostalgic glimpse into a bygone era of seaside fun.

Acknowledgements

I would like to thank Campbell McCutcheon (*CMcC*), of Amberley Publishing, for commissioning this book on my home town and for supplying several pictures from his extensive collection of old postcards. For additional images I am grateful to Bournemouth 200 Virtual Museum (*Bmth200*) for kindly letting me use some excellent images from their archive (you can see more from them on Flickr). I must also thank Arpingstone, the US Library of Congress (*LoC*) and the Bournemouth Image Library (*BIL*). For photos of the preserved buses I am grateful to Ultra7, S. P. Smiler, and to Helen and Mike Pursey. Unless otherwise credited all new photography is by the author (*JC*). I must also thank my wife Ute for proofreading and patience, and my sister Ella Christopher for her assistance in Bournemouth.